DOWN BELOW
ABOARD THE WORLD'S CLASSIC YACHTS

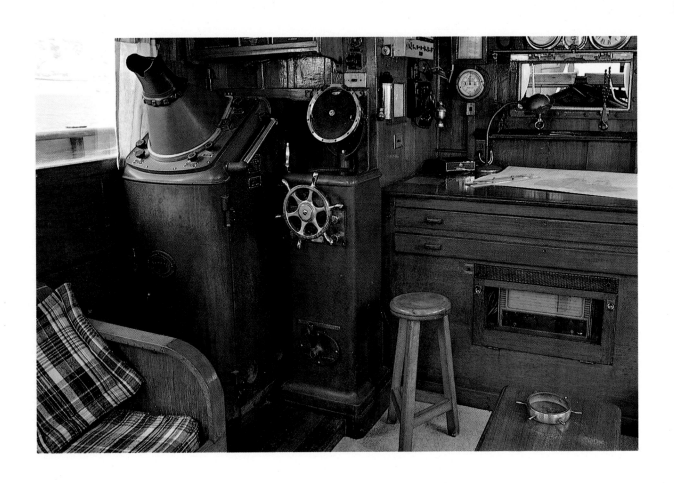

DOWN BELOW

ABOARD THE WORLD'S CLASSIC YACHTS

MATTHEW WALKER

Chronicle Books
San Francisco
A Prism Edition

To My Parents

Book and cover design by Bill Yenne
Composition by Design & Type, Inc.
Printed by Dai Nippon, Tokyo, Japan

Library of Congress Cataloging in Publication Data

Walker, Matthew, 1949–
Down Below.

"A prism edition."
1. Yachts and yachting. I. Title.
VM331.W26 387.2'23 80-12327
10 9 8 7 6 5 4 3 2 1

Acknowledgement is made to the following individuals and corporations for exterior photographs of yachts listed, with additional interior views where noted. All other photographs are by the author and are reproduced with the consent of the yacht owners. GAUCHO—Marianne Sutherland, Johannesburg; TERN IV—Steve Parsons; TICONDEROGA—Copyright © 1978, Jim Brown, Marblehead, Massachusetts; WHITEHAWK—Stephen Rubicam Photography, Boothbay Harbor, Maine; STROVILI—Kavos Yachts, Piraeus; FAIR SARAE—Lucy Bancroft, San Francisco, California; GROOTE BEER—Howard Luray, Seattle, Washington; DAUNTLESS—Diane Beeston, San Francisco, California; XEBEC—Edward & Jacqueline Ogley, Saint Thomas, Virgin Islands; ANGELA—Valef Yachts, Piraeus; DOXA I—Valef Yachts, Piraeus; IRENE—Stavros Tsatalios, Piraeus (also main salon photograph); ZORRA—Tony Finchman; SIROCCO—James Steivang, Saint Thomas, Virgin Islands; JACARANDA—Astilleros Viudes, Barcelona (also interior views); SOLARIA TOO—Chantiers Navals de l'Esterel, Cannes; SEA CLOUD—Stanley Rosenfeld, New York; UNICORN—Unicorn Maritime Institute, Tampa, Florida; LINDØ—Chris Blackwell, Saint Thomas, Virgin Islands; MARIE von Altona—Joachim Kaiser, Hamburg; ANTARES—Dave Ferneding, Saint Thomas, Virgin Islands; ALICANTE—William Purdy, Burlingame, California; PRETANTAINE—Sebastian Schaffer, Piraeus; HAWAITA—Howard and Roe Ann Ford, Venice, California.
 Photographs by the author were taken using Kodachrome-25 daylight/positive color film and the CANON "F-1" Professional 35mm single-lens reflex camera system. Interior illumination, when needed, was daylight-balanced 500-watt incandescent photoflood. All photographs processed by Eastman Kodak in San Francisco, New York, and Paris.

Contents

Introduction

There is a new current flowing in the world of yachts today. Those individuals who honor both tradition and modern craftsmanship in boatbuilding have joined a rising tide of interested sailors, and it is a mark of our time that their numbers are increasing.

In DOWN BELOW, Matthew Walker leads one on a journey through an international fleet of classic yachts, an inside look normally hidden from the public. Although his combined experience as a boatbuilder, writer, and photographer qualifies him as a guide, these talents are enhanced with a rare understanding and affection for his subject. The text in these pages gives substance to the yacht-owners, often indicating how closely their personalities and their yachts are matched.

The camera, however, reveals the photographer as well as his subject. The images which follow are rich in detail, illumination, color, and mood, for an invisible caress has entered this secret realm. DOWN BELOW is a book welcoming the general reader as much as the experienced sailor—a document for all who dream of the sea.

Stanley Rosenfeld

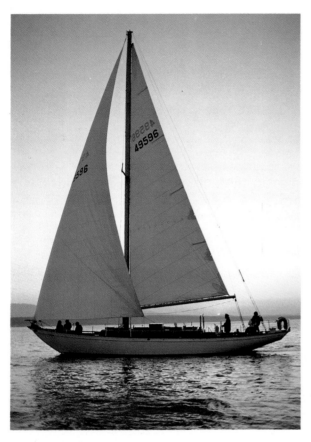

Condor

When Franz Schattauer of Seattle, Washington, advertises his services as a "master sailmaker," it isn't an idle boast. He was raised in Bremerhaven, Germany, and learned his trade when a man had to prove himself before being called an expert. In Schattauer's own case, that meant four-year apprenticeship to an established sailmaker, followed by ten years at journeyman status, with another year of schooling in Hamburg before final exams. He can work canvas or synthetic cloth and his wire-splices would pass inspection by Lloyd's of London. The boats for which he's made sails range from skiffs to squareriggers.

Franz Schattauer is very proud of German craftsmanship. That pride has paid off: having given sons Axel and Frank both sailmaking skills and, as he says, "an eye for quality," Schattauer relied on them for advice when it came time to buy a classic wooden sailboat—not necessarily one with a fancy pedigree, but something comfortable, well-built and fast.

The yacht's name at time of purchase was **NUNAGA**, and she was all that the Schattauers had wanted. In addition, she does have quite a history. Research in old boating magazines proved that the sloop had originally sailed with a yawl rig for Bradley P. Noyes of the Eastern Yacht Club, Marblehead, Massachusetts. Under the name **TIOGA**, she had won six out of seven starts in the 1955 New York Yacht Club races, along with other ocean events. Of the 1955 Havana Race, *Yachting* Magazine said, "There wasn't a slicker performer down south than Brad Noyes' **TIOGA**. Aage Neilson has designed a crazy devil to windward that runs and reaches superbly well, too."

Further research revealed that **TIOGA** had once sunk during a hurricane, and that Maine boatbuilder Paul Luke had salvaged and completely repaired the hull. That episode gave the future **CONDOR** an unusually bright interior, with the colors of sky-blue enamel and natural wood, but without changing her very practical cruising accommodations. The boat was later donated to the Maine Maritime Academy by sailor William Ziegler and eventually made her way to the American Northwest. Through heavy use and many owners, the boat had endured, and the Schattauers' renovation work constantly brings to light **CONDOR**'s hidden value.

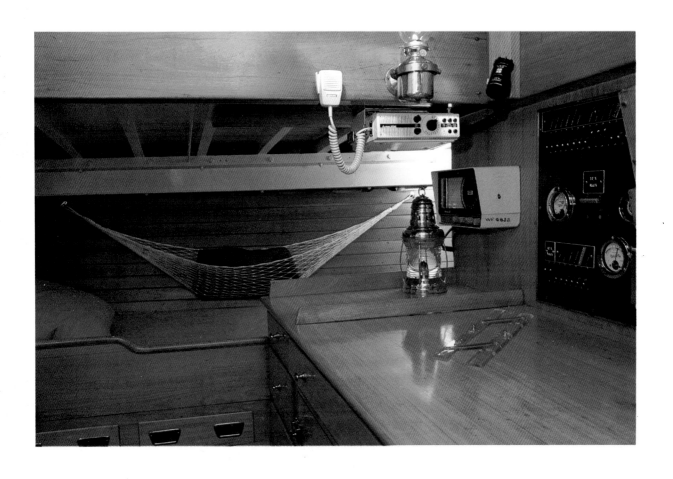

Designer—K. Aage Neilson

Builder—Cantieri Baglietto; Varazze, Italy
(launched 1954)

Length—50 feet (15.24 meters) overall; 34 feet 3 inches
(10.44 meters) at waterline

Beam Maximum—12 feet 6 inches (3.81 meters)

Draft—5 feet 10 inches (1.78 meters); 9 feet (2.74 meters)
centerboard down

Displacement—32,000 pounds (14,518 kilograms)

Total Sail Area—1370 square feet (127 square meters)
sloop rig with 150% genoa

Engine Data—37 horsepower Westerbeke diesel

Construction—double planked, Honduras mahogany
over white cedar, bronze-riveted on oak
frames, mahogany keel; bronze-strapped,
bronze floors; peruba interior, teak decks;
new aluminum spars, polyester sails

Home Port—Seattle, Washington, U.S.A.

Blue Peter

While travelling in the northwestern United States, it might be worth counting how many bridges, navy destroyers, and ferryboats carry the inscription of H.W. McCurdy's "Puget Sound Bridge and Drydock Company," or how often that company built entire airfields, city harbors and installations along America's Distant Early Warning Radar System (D.E.W. Line).

But these bare facts don't do justice to the man. For that you would have to see McCurdy's autobiography, and you'd work hard to find it, because only 250 privately printed copies were distributed to close friends. The book is called *Don't Leave Any Holidays*, and its title comes from those dry spots you get when you're not careful with the varnish. If you read that book, as I did while aboard the motoryacht **BLUE PETER** (named after the flag hoisted twenty-four hours before a ship's departure),

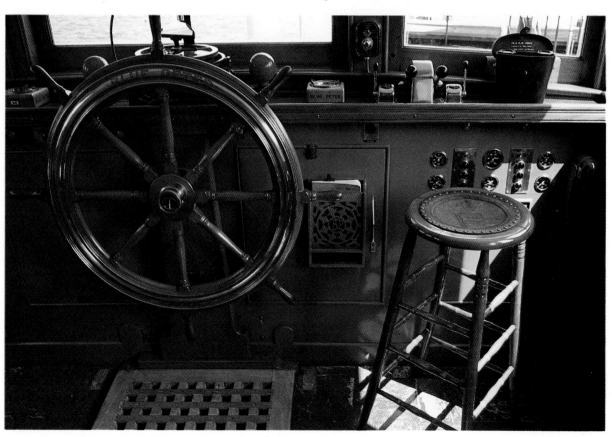

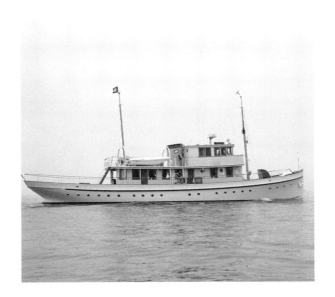

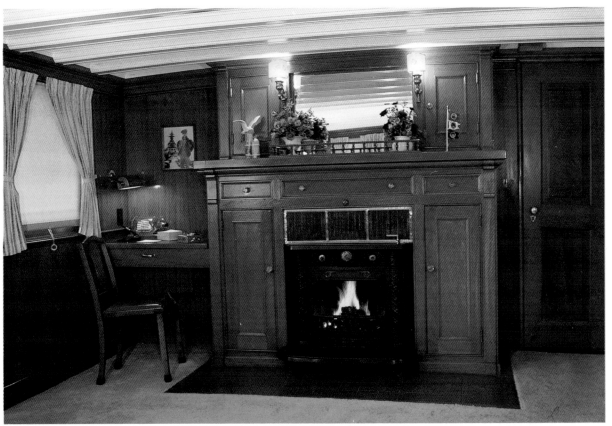

you may wonder how a man could squeeze so much work and play into one lifetime.

Mac (as McCurdy prefers to be called) grew up delivering newspapers and working aboard pile drivers in Port Townsend, Washington, in the years when that city's harbor often had thirty big squareriggers at anchor, waiting for cargoes of lumber, grain, and salmon. His father, James Griffith McCurdy, had been crippled by polio but had made his way in local banking, and Mac's uncle ran a small shipyard. Mac's grandfather, William Augustus, had worked in Boston, Massachusetts, with the famous shipwright Donald McKay and had sailed to the western frontier in 1857; there William Augustus married the seventeen-year-old Johanna Ebinger, whose Wisconsin family had crossed over on the Oregon Trail when she was a child of three.

Although both were highly industrious, neither William Augustus McCurdy nor son James Griffith could leave their family any kind of fortune, and Mac

later went on to the University of Washington and a degree in mechanical engineering at Massachusetts Institute of Technology (where he captained the varsity rowing crew). While at M.I.T., and when courting his future wife Catharine McManus in the early 1920s, Mac took her in a rented rowboat to circle the millionaires' steamyachts off Marblehead, Massachusetts. He remembers wishing that somebody aboard the sleek **CONSTELLATION, ATLANTIC, ALOHA**, or J.P. Morgan's **CORSAIR** would invite them aboard for a peek at the good life, but it never happened.

When **BLUE PETER** was acquired at an Army surplus sale after World War II, McCurdy brought her to his shipyard and supervised the renovation of areas torn out during Army service. It's worth mention that in many a harbor around Puget Sound today, children recall "when H.W. McCurdy himself came to the aft-deck of his yacht, hailed us in our little dory, and asked if we'd join a raid on **BLUE PETER**'s cookie-jar."

Designer—L.E. "Ted" Geary
Builder—Lake Union Drydock Company; Seattle, Washington (launched 1928)
Length—96 feet (29.26 meters) overall; 86 feet (26.21 meters) at waterline
Beam Maximum—18 feet 4 inches (5.59 meters)
Draft—10 feet (3.05 meters)
Displacement—264,480 pounds (120,000 kilograms)
Engine Data—two Caterpillar diesels, 330 horsepower each
Construction—Port Orford cedar and fir over double-sawn yellow cedar frames; teak-over-cedar decks; mahogany/teak interior
Home Port—Seattle, Washington, U.S.A.

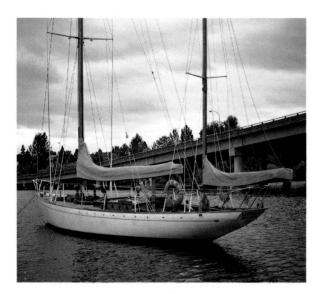

Dorade

In 1931, ten yachts left Rhode Island at the start of that year's Transatlantic Race. One arrived in England after seventeen days—not a record, but two days faster than any other American or British yacht in the race. The yawl **DORADE** had braved the stormy North Atlantic, a route previously left to huge schooner yachts with professional crews, so her victory marked the beginning of something new in ocean racing: small boats sailed by amateurs.

DORADE's crew included Rod Stephens, who financed construction, along with two talented sons, designer/skipper Olin and younger brother Rod, Junior. The fact that Olin Stephens was only twenty-one when he designed **DORADE** may have earned that loud parade upon return to New York City, and just in case anybody attributed the Transatlantic win merely to good luck, **DORADE** later took two of Britain's Fastnet Races, the 1932 Bermuda Race (Class B), and the 1935 run from San Francisco to Honolulu.

All these facts are easily forgotten. On a quiet dock in Seattle, Washington, I heard someone ask, "Why name that sailboat after dorade vents?" The answer was that **DORADE**'s wind-scoops were built with a chamber to separate spray from ventilating air, and the design took on the boat's name. This and other details of the famous racer were lost neither on J. Franklin Eddy, who owned **DORADE** in Seattle until his death in 1978, nor on historic Mystic Seaport in Connecticut, which acquired the yawl according to the terms of Eddy's will. Then the administrators of Mystic Seaport asked Seattle yacht-broker Bates McKee, Jr., to find her a good home. Considering that Olin Stephens went on to design, among many other famous vessels, the America's Cup defenders **COLUMBIA, CONSTELLATION, INTREPID,** and **COURAGEOUS**, one could not call **DORADE** a true masterpiece, and she would offer limited educational value to even the most innovative maritime museum.

Despite her rather cramped accommodations, someone else has nonetheless discovered the joys of riding this lean, submarine-like yacht. Soon after finding new owners, **DORADE** was out sailing again and, yes, did suffer a collision in one regatta (the other boat sank), but the yawl seemed ready for another fifty years.

Designer—Olin Stephens

Builder—Minneford's Yacht Yard; City Island, New York
 (launched 1930)

Length—52 feet 6 inches (16 meters) overall; 39 feet (11.89
 meters) at waterline

Beam Maximum—10 feet 3 inches (3.12 meters)

Draft—8 feet (2.44 meters)

Displacement—37,800 pounds (17,150 kilograms)

Total Sail Area—1200 square feet (111.5 square meters)

Engine Data—37 horsepower Perkins diesel

Construction—Honduras mahogany bronze-fastened on
 oak frames, fir deck; mahogany interior,
 spruce spars, polyester sails

Home Port—Seattle, Washington, U.S.A.

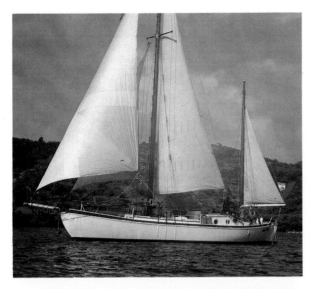

Gaucho

In 1939, Ernesto Uriburu was in the United States as First Secretary of the Argentine Embassy. His diplomatic service had him in Philadelphia, the birthplace of America's freedom, yet Uriburu felt trapped, his life and imagination not on good terms with each other. Years later, in a book entitled *Seagoing Gaucho*, he described the logical steps taken to obtain his freedom.

First, he purchased a compass. Not some plastic-wrapped imitation, but an authentic mariner's compass —perfectly balanced on polished gimbals, and utterly useless in Philadelphia. His memories of those days:

> So the compass stays by my bed. It is the last thing I look at before I fall asleep, and the first thing I peek at before I get up. I look at it quite a bit in-between-times, and weave a few daydreams around it. But it is a long time before I admit even to myself why I have bought the compass. It it because I intend to build a boat around it.

The second step toward freedom was summoning his brother from Buenos Aires:

> Bobby is an old and genuine salt. He knows all about boats—how to design them, how to navigate them, how to care for them. On top of that he can write very good sea tales, in Spanish, when he is not having love affairs, which is when he has not spoiled everything by snoring. He snores like a walrus.

GAUCHO is the tough double-ender which Ernesto envisioned. Even during World War II, he scraped together the money to keep construction going, and it was to be a masterpiece, designed by the great Manuel Campos. An earlier design by Campos had been the smaller **LEHG II**, which another famous Argentine, Vito Dumas, sailed singlehanded around the world. The talented sons of José Parodi, who built **LEHG II**, were chosen to build **GAUCHO**:

They are craftsmen, and they are very inconveniently happy, and so are their workmen. When it rains, everybody knocks off. When somebody has a birthday, everybody knocks off. When nobody has a birthday, everybody knocks off to console each other.

The tales told of **GAUCHO** after launch would fill a library. The Uriburus gave their ketch a bowsprit, changed mainsail from gaff-rig to simple Bermuda triangle, and off they went to Rio de Janeiro, Dakar, the Canary Islands, Cadiz, Gibraltar, Alexandria, Messina, Nassau, New York, Miami, Havana, Port-au-Prince, and Barbados. They saw astounding sights, enjoyed parties everywhere, and finally earned the Cruising Club of America's coveted Blue Water Medal.

Then an American family, Tony and Nanci Badger and daughters Jody and Lauren, bought **GAUCHO**. She sailed again, through the Caribbean, to Panama, the Galapagos Islands, and home to California. In 1969, the boat got a new mast, engine, decks refastened and hull recaulked, and sailed off to Nicaragua, Florida, Bermuda, the Azores, and Madeira. Then came the 3800-mile, thirty-two-day return passage from the Canaries to Brazil, and finally to Argentina to meet Manuel Campos.

By 1976, the Badgers had sold **GAUCHO** to Douglas and Marianne Sutherland, a young couple from South Africa. Soon their children, Robert, Andrew, and Jacqueline, came over from Johannesburg, and **GAUCHO** was sailing again, keeping the old compass hard at work.

Designer—Manuel Campos

Builders—Lorenzo & Alfredo Parodi; Tigre, Argentina (launched 1943)

Length—58 feet (17.68 meters) overall; 50 feet (15.24 meters) on deck; 42 feet (12.80 meters) at waterline

Beam Maximum—14 feet (4.27 meters)

Draft—7 feet (2.13 meters)

Displacement—77,140 pounds (35,000 kilograms)

Total Sail Area—1000 square feet (92.9 square meters)

Engine Data—Ford 120 horsepower diesel

Construction—lapacho (toxic ironwood) plank below waterline, viraro plank above waterline; viraro frames, lapacho keel, bronze-fastened; cedro ceiling, pediribi/cedro deck on viraro beams; cedro interior, fir spars, polyester sails (original sails were Argentine cotton)

Home Port—Saint Thomas, Virgin Islands

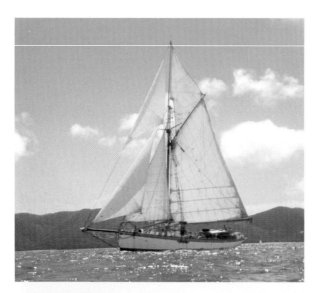

Tern IV

Any dinner guest aboard **TERN IV** first receives Joy Fothergill's warm and affectionate reception and then a taste of Seven Seasons Soup. There is no recipe, and even husband Roger admits The Soup varies in quality, but besides traces of the original mixture, selected leftovers, and unexplained spices, there are always at least seven fresh vegetables among the ingredients. Joy simmers The Soup often, and she plans its transfer to the Fothergill heirs.

When supper is at hand, Roger Fothergill proceeds to some lively discussion of Claud Worth, the yacht designer who was not a yacht designer and now, in the form of a ghost, haunts his old **TERN IV**. In the unlikely event your attention wanders, Mr. Fothergill may quote from Claude Worth's book, *Yacht Navigation and Voyaging*:

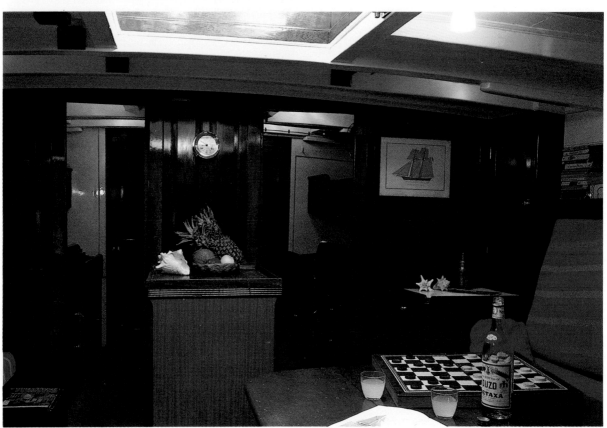

TERN III was the result of experience of all the yachts which I had owned and of many years' study of design and construction, which has always been a favorite hobby. Believing her to be the most perfect deep-water cruiser of her size, I did not imagine that I should ever build another....An eminent house architect is reported to have said that the only way in which an architect could produce a really perfect house would be to study the plans for a year, build the house regardless of cost, live in it himself for five years, and then build another.

TERN IV was Claud Worth's "really perfect" yacht. As a medical man, his opinions concerning yacht design were logically the subject of warm debate, so he would be pleased to see how well the Fothergills maintain his masterpiece. Some temporary changes are visible: the tiny mizzen-mast is gone, leaving the yacht cutter-rigged, and her mainsail now brails against the mast instead of lowering to the deck, but these changes help a small crew working Caribbean charters. Roger Fothergill sails with "a minimum of chronic gadgets, only a depth-sounder and radio for emergencies, at which times only a fool stands on ceremony." Waterheaters and air-conditioning are entirely absent.

Designer—Claud Worth

Builder—Philip & Son; Dartmouth, England (launched 1924)

Length—76 feet (23.2 meters) overall; 62 feet (18.9 meters) on deck; 49 feet 6 inches (15.1 meters) at waterline

Beam Maximum—13 feet 6 inches (4.11 meters)

Draft—8 feet 6 inches (2.59 meters)

Displacement—83,752 pounds (38,000 kilograms) Thames Measurement Tonnage

Total Sail Area—2000 square feet (186 square meters) cutter rig; "raffee" topsail and squaresail added downwind

Engine Data—Perkins 62 horsepower diesel

Construction—Burma teak plank (except American elm garboard and "first plank") on English oak frames and keel, bronze-fastened; teak deck on oak beams, Honduras mahogany interior; new fir mast and bowsprit, spruce topmast, polyester sails

Home Port—Saint Thomas, Virgin Islands

Ticonderoga

When the big seventy-two-foot ketch **TIOGA** was launched in 1936, most of the old salts attending were well-prepared, depending upon various omens, to predict the boat's future. Come to think of it, considering the percentage of high-quality embalming fluid found in the average sailor's blood during such events, those old men may have been equally prepared for their heavenly ascent.

TIOGA's future owner, Harry E. Noyes of Marblehead, Massachusetts, had given responsibility for the christening to his eleven-year-old daughter Helen; a local newspaper reported that she "swung the champagne bottle with the decisive finality of a ballplayer hitting a home run, and the shattering of the bottle...seemed to push the new yacht right down the ways." But **TIOGA** had just cleared the boatshop doors when the launching cradle suddenly collapsed! The yacht rolled to starboard, continued to rumble down the ways, rolled miraculously back on an even keel, made it unharmed into the water, and came to an abrupt halt by thumping a conveniently positioned motoryacht. The verdict? Surprisingly, the launch was seen as proof that **TIOGA** would weather all manner of misfortune, for she carried the luck of the sea.

Harry Noyes had commissioned L. Francis Herreshoff to design a larger version of an earlier fifty-seven-foot ketch, which had also been called **TIOGA**, a name associated with the Noyes family. The new boat was likewise to be a comfortable family cruiser, built without concern for race-measurement rules, but Herreshoff gave **TIOGA** more than just good looks. Despite the central heating, refrigerators, bathtub, hot and cold running water, ship-to-shore telephones, and oversize fuel/water tanks, the new ketch was unbelievably straight-ahead fast!

Even before service with the U.S. Coast Guard during World War II, **TIOGA** broke race records along

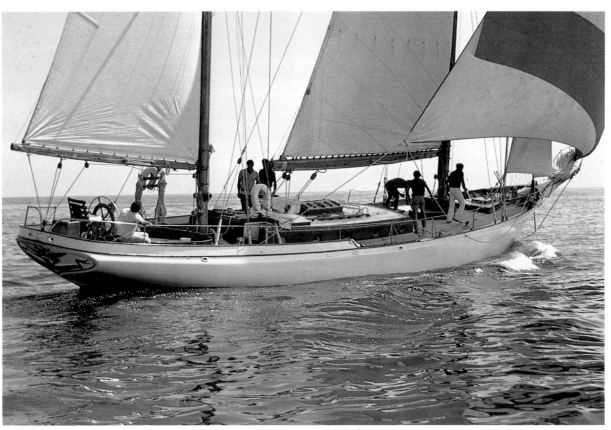

America's east coast; after the war, she received the new name **TICONDEROGA**. By 1967, when her racing career ended and her hull was rebuilt, "Big **TI**" had sailed many thousands of miles, at one point holding over thirty major records in world ocean racing.

Today, Herreshoff's acknowledged favorite is in the Caribbean charter trade, seemingly a step down from her first-to-finish racing years. The heavy equipment needed for charter guests makes **TICONDEROGA** anything but a racing-machine, yet the Herreshoff magic lingers on. When Ken and Fran MacKenzie of Newport, Rhode Island casually entered their ketch in the 1978 Guadeloupe Race, they felt safe enough to bring along a new addition to the MacKenzie family: five-month-old Margaret. And they won.

Designer—L. Francis Herreshoff

Builder—Quincy Adams Yacht Yard; Quincy, Massachusetts (launched 1936)

Length—85 feet (25.9 meters) overall; 72 feet (21.94 meters) on deck; 63 feet 10 inches (19.46 meters) at waterline

Beam Maximum—16 feet (4.88 meters)

Draft—7 feet 10 inches (2.39 meters)

Displacement—119,016 pounds (54,000 kilograms)

Total Sail Area—2800 square feet (260 square meters)

Engine Data—GMC 130 horsepower diesel

Construction—double mahogany plank on new laminated oak frames, oak keel, bronze floors/mast-step; teak decks on oak beams, new teak/mahogany interior; spruce spars, polyester sails

Home Port—Newport, Rhode Island, U.S.A. (winters in Antigua)

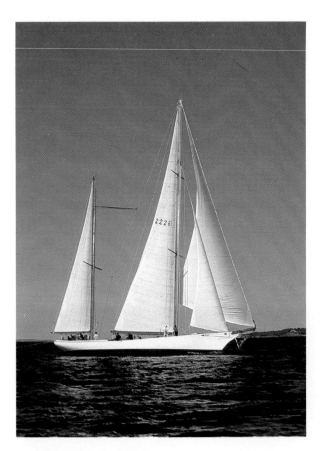

Whitehawk

O. Lie-Nielson was eighteen years old in 1926 when he left Oslo, Norway, and emigrated to Boston, Massachusetts. After arrival, he enlisted in the U.S. Marines, served his two years in Nicaragua, and returned to the U.S.A. looking for work. By age twenty-three, the young man whose father had been a college president was doing well in a very different profession—boatbuilding. The yacht designer with whom Lie-Nielson found work was none other than L. Francis Herreshoff, who was then directing construction of a 72-foot ketch named **TIOGA**. Years later, that boat became famous with the name **TICONDEROGA**, and along the way the young Norwegian spent three years as her captain.

Soon "Lee's Boat Shop" became well-known along the Maine coast, and the proprietor had earned a few grey hairs. Some of the skilled men who had also trained under Herreshoff now worked in the Maine shop, so there was a certain nostalgia when Lie-Nielson restored the ketch **BOUNTY**, which Herreshoff had designed before **TICONDEROGA**. Those were the years when many sailors had become skeptical, feeling that large yachts would never again be built with old-fashioned craftsmanship; the top of Lie-Nielson's head would be snow-white before he and naval architect Bruce King proved the skeptics wrong.

It began when Californian Phil Long decided to commission something larger than **BOUNTY** (which he had purchased from Lie-Nielson) or even the great **TICONDEROGA**. The new yacht would be a 92-foot version of **TICONDEROGA**, but proportionally lighter and with greater sail area; the hull was to be constructed entirely of wood, using the "wood/epoxy saturation technique" (W.E.S.T.) system perfected and trademarked by Gougeon Brothers of Michigan.

WHITEHAWK took twelve to fifteen men, working full-time for three years, to build. Nearly all the woodworking and machining of bronze, steel, and aluminum hardware was done in Lee's Boat Shop; even the 53,000-pound lead keel was poured by the shop crew. Cost estimates run to over two million dollars, and long after **WHITEHAWK** had been sold to retired insurance executive Thomas Zetkov, work was still being done on deck gear and accommodations. Despite an abundance of machinery added for comfortable long-distance cruising, the yacht's interior displays a classic reverence for natural wood.

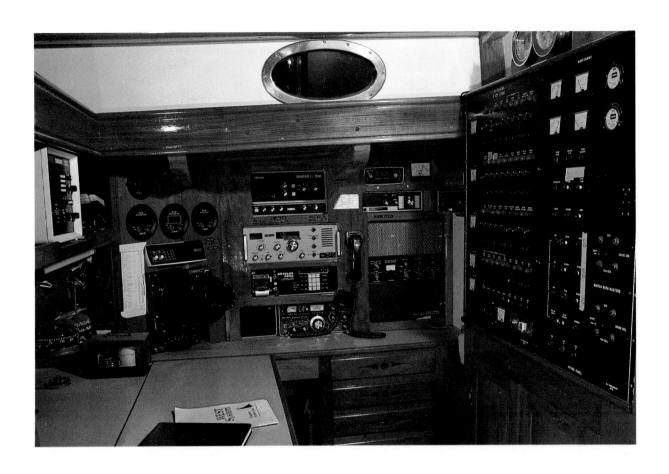

At her launch, with bagpipe music and the sounds of champagne, there was every kind of sentiment expressed about the new **WHITEHAWK**, but one opinion provoked a response worth repeating: "Mister, steady work is hard to come by sometimes in Maine. Building this boat fed a lot of men and their families, and she's a pure inspiration to every young boatbuilder who sees her. That white-haired Norwegian learned a lot from old Herreshoff."

Designer—Bruce P. King
Builder—O. Lie-Nielson; project supervisors William Peterson and Eric Lie-Nielson (launched 1978)
Length—109 feet (33.22 meters) overall; 92 feet (28.04 meters) on deck; 78 feet 6 inches (23.93 meters) at waterline
Beam Maximum—20 feet 6 inches (6.25 meters)

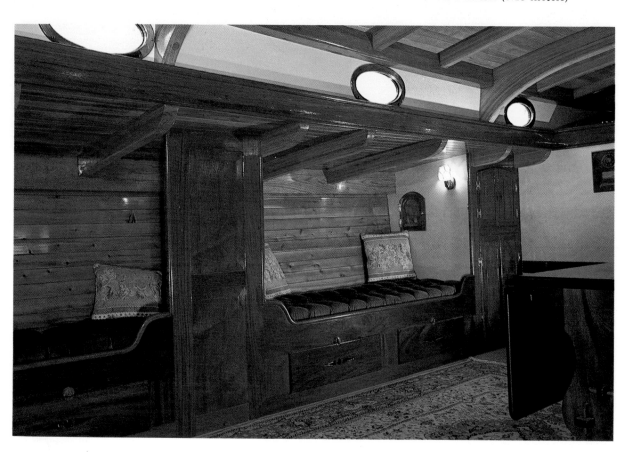

Draft—7 feet 5 inches (2.26 meters); 16 feet 10 inches (5.13 meters) hydraulic daggerboard down

Displacement—165,000 pounds (74,861 kilograms)

Total Sail Area—4484 square feet (417 square meters)

Engine Data—310 horsepower Detroit Diesel

Construction—hull laminate 2½ inches (6.35 centimeters) thick; three diagonal layers of cedar veneer, bronze-nailed and bonded with epoxy adhesive over longitudinal cedar strip-plank, with exterior veneer layer of longitudinal mahogany applied with plugged bronze screws; entire inside and outside hull surfaces saturated with epoxy resin; yellow pine floor-timbers, laminated white oak keelson and sheerclamp; teak deck over laminated cedar on oak beams; interior mahogany, teak, oak, cedar; spruce spars, polyester sails

Home Port—Rockland, Maine, U.S.A.

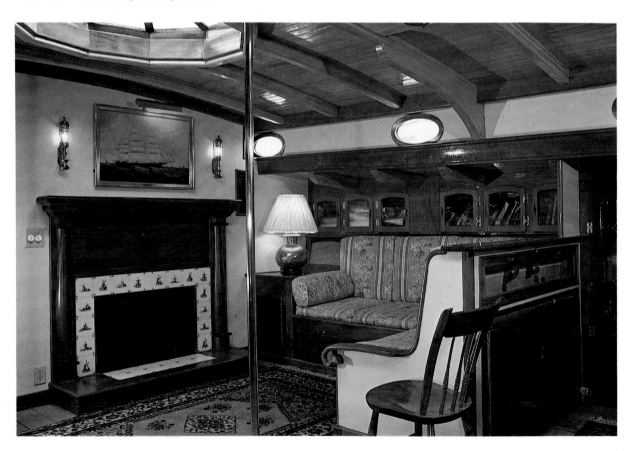

Sfizio & Stradivari

When I was very young and life was very simple, my family lived by the Bay of Naples. One sister and my brother were born there, in the shadow of the old volcano Vesuvius, and whenever sunrise awakened birds around the emerald Bay, we understood why Italians claim that even angels learn to sing in Napoli.

But only Neapolitans speak Neapolitan. Theirs is "the ungovernable city"—an ancient seaport where the finest works of art and the foulest garbage thrive together, a place which still has a style and dialect all its own. While Napoli once acquired fame from the superb hemp it grew for ropemaking, now the city is just as famous for having grown movie-actress Sophia Loren. Napoli also has some of the world's most talented drivers, any one of them able to take a car 1.8 meters wide through an opening only 1.7 meters wide—without a scratch.

That is the Neapolitan "sfizio." The word simply cannot be translated into English, and naval architect Mino Simeone insists it can't be translated into Italian! He ventures that someone or something may deserve the adjective "sfizioso," but the abstract noun itself defies explanation: "When is a joke—a deception—important because it is unimportant? Sfizio! What makes life worth living when it isn't worth it? Sfizio!"

Mino Simeone doesn't fit most people's image of a naval architect. He is tall, lean, with a dark beard and sparkling eyes which hint at his Russian ancestry. On weekend mornings, Simeone and his wife Marina arrive early on the waterfront, driving a Fiat five-speed Spyder convertible; as soon as sails are hoisted aboard the family yacht, the racing which the Simeones do for relaxation during the next eight hours is more strenuous than what most people do for work.

SFIZIO was designed to compete at the so-called "Quarter-Ton" level under today's International Off-

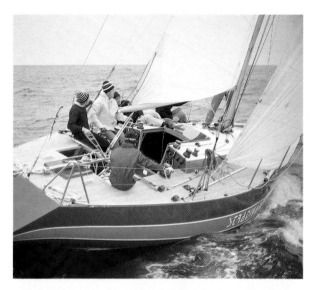

shore Rule, a measurement system which Simeone helps to supervise. As a member of the Special Regulations Committee of the Offshore Racing Council, Simeone handles the complex mathematics required to close loopholes in the Rule, and to these responsibilities he adds the skills of a professional boatbuilder. Even a quick tour of his favorite yacht-clubs produces a long list of sleek wooden racers made in the "Cantieri Simeone" boatshop.

STRADIVARI was built for a client obviously aware of the similarities between a masterpiece violin and a lightweight racing sailboat. This larger (Three/Quarter-Ton) yacht is owned by musician Antonio Fiorentino, who commissioned Simeone to design a comfortable cruiser nevertheless able to win the Three/Quarter-Ton World Championship in Denmark. **STRADIVARI** has far more equipment and interior accommodations than a small "weekender" such as **SFIZIO**, but Fiorentino's finely tuned racer displays just as much concern for low weight and high speed; both yachts have extremely flexible masts and every conceivable go-fast control for their generous sailplans.

SFIZIO (launched 1979)
Length—7.71 meters (25 feet 3 inches) overall, 6.50 meters (21.33 feet) at waterline
Beam Maximum—2.7 meters (8 feet 10 inches)
Draft—1.51 meters (4 feet 11 inches)
Displacement—1382 kilograms (3046 pounds)
Sail Area—36.15 square meters (389 square feet), with #1 genoa; no engine aboard
Construction—Canadian red cedar strip-plank, bronze nails and resorcinol glue over laminated ash and elm frames; hull sealed with epoxy resin; interior mahogany plywood, aluminum spars, polyester sails; deck fiberglass-sheathed

STRADIVARI (launched 1978)
Length—10.34 meters (33 feet 11 inches) overall, 8.54 meters (28.02 feet) at waterline
Beam Maximum—3.29 meters (10 feet 9 inches)
Draft—1.78 meters (5 feet 10 inches)
Displacement—3900 kilograms (8596 pounds)
Sail Area—66 square meters (710 square feet), with #1 genoa
Engine Data—Faryman 12-horsepower diesel
Construction—mahogany strip-plank, bronze nails and resorcinol glue over laminated elm frames; hull epoxy-sealed; deck is teak strips glued over mahogany plywood and okume laminate; interior mahogany plywood, aluminum spars, polyester sails

Strovili

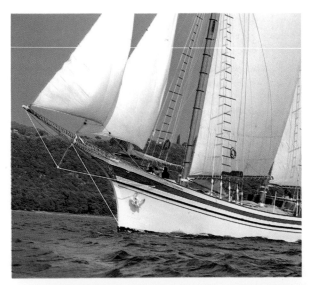

I f the men who come from Samos are all like Constantin Vacoletos, then the women living on that Greek island must have their hands full. Vacoletos is captain of the schooner **STROVILI**, and the night he and I took some friends to an Athens restaurant, he never let the wine-bottle get half-empty before ordering another, then we almost started a fight when both volunteered to pay the check, and he finished off the evening by dancing wildly to the bouzouki music and throwing bank-notes to the musicians. Vacoletos is seventy-four years old.

White hair or not, **STROVILI**'s captain also runs a very active ship. With a black cigarette holder clenched between his teeth and with hands clasped behind him, Vacoletos will check every portion of the schooner, ordering his crew to polish this and paint that, getting **STROVILI** ready for the next arriving group of vaca-

tioners. The captain has an equally capable agent to direct his charter schedule: Mrs. Aleca Trillard-Kavageorgis of Kavos Yachts in Piraeus. Reservations to sail aboard **STROVILI** come in many languages and from all over the world, so Kavos must handle details including which islands the schooner will visit, what the menu will be aboard, and even the available selection of wines.

STROVILI (meaning "storm") was originally named **PANDORA**, had been built for the late Panagiotis Lemos, and is now owned by his son, Markos Lemos of London, England. This schooner and her larger sister **AETOS** ("eagle") are examples of how well Greek yacht-builders can develop traditional appearance with the modern sailor in mind, for **STROVILI** contains almost everything a luxury hotel could offer, neatly packaged in a strong, seaworthy hull. Like the coastal sailing vessels which for centuries transported much of the world's cargo, **STROVILI** offers tremendous interior volume, providing her lucky guests with a sense of freedom normally encountered only aboard expensive cruise-ships.

Designer—Petroutsis, Piraeus
Builder—G. Psaros Shipyard, Piraeus (launched 1962)
Length—34.0 meters (111 feet 6 inches) overall; 27.8 meters (91 feet 2 inches) on deck; 25.0 meters (82 feet) at waterline
Beam Maximum—6.25 meters (20 feet 6 inches)
Draft—3.97 meters (13 feet)
Displacement—157,000 kilograms (346,028 pounds)
Total Sail Area—500 square meters (5380 square feet)
Engine Data—Mercedes/Benz 265 horsepower diesel
Construction—"pefko" pitchpine throughout, bronze-fastened; teak deck, mahogany interior; Norway spruce hollow spars, polyester sails
Home Port—Pasalimani, Piraeus, Greece

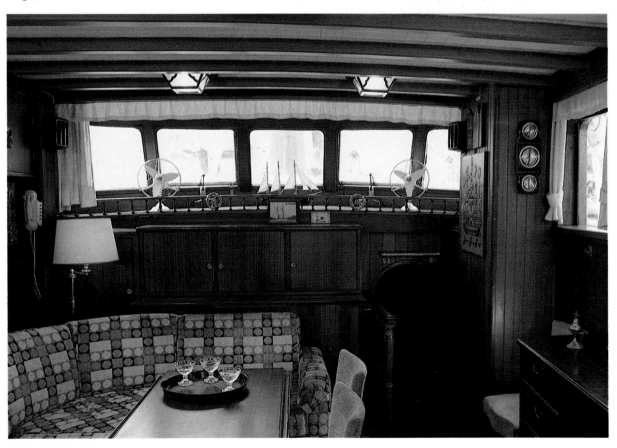

Eilean

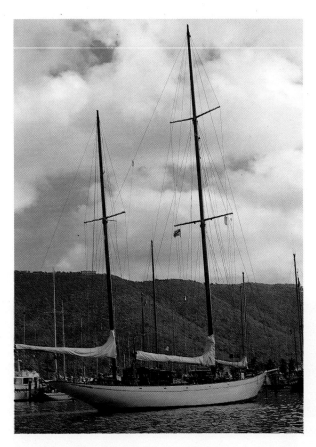

Asking any group of sailors to define the "classic yacht" would create more noise than common sense, but there is one name which might produce agreement—William Fife. The name belonged to a father and later to his talented son, and the vessels they built by the River Clyde before and after the turn of this century did more than please the King of England, the German Emperor, and Sir Thomas Lipton. The Fife legacy has become the standard by which other yachts are judged.

EILEAN is among the handful of Fife boats which remain. She is unusual in that her original appearance survived, and what little alteration was done through the years has been erased under the recent care of John Shearer. He claims that the restoration was accomplished, not to please the many Fife fanatics, but because the ketch's basic design was flawless and deserved to stay, yet even the Lloyd's Register sail-number (#449) assigned at launch remains, along with the distinctive Fife "golden dragon" emblem painted at her bow. The yacht's unchanged interior is exceptionally quiet and well-insulated, with rich oak panelling to eliminate the gloom normally encountered with darker woods. Shearer remembers that the name **EILEAN** comes from the Scots word for a small island and was given by the first owner, James Fulton of Greenock.

The ketch has had comparatively few owners during her life, some of whom were a bit eccentric. One in particular seems to have been an important Labor Party leader, who chose an English election campaign as the occasion for boldly painting "VOTE TORY" on the sides of his yacht, evidently to advertise the Conservative Party's love of inherited wealth; the plan backfired when the yacht's true ownership became public knowledge. Another owner was an American businessman of mysterious circumstance, whose talkative daughter became famous in the Caribbean simply as "Miss Daddy-Has-a-Million-Dollars."

Shearer feels strongly that the composite construction used in building **EILEAN** (as well as the famous clippership **CUTTY SARK**) is an excellent method when carefully applied, for the well-maintained ketch has never suffered from excessive corrosion and leaks not at all. Critics might say the Fife design philosophy of "what looks right is right" did not always win races, but the charter agents at Ocean Enterprises on Saint Thomas have found that vacation guests always prefer a beautiful and seaworthy classic over an uncompromised and uncomfortable speed machine, and that's when **EILEAN** looks very right indeed.

Designer/Builder—William Fife, Junior; Fairlie, Scotland (launched 1937)

Length—84 feet (25.6 meters) overall; 72 feet 4 inches (22.05 meters) on deck; 50 feet 11 inches (15.52 meters) at waterline

Beam Maximum—15 feet 10 inches (4.65 meters)

Draft—10 feet 8 inches (3.25 meters)

Displacement—132,240 pounds (60,000 kilograms)

Total Sail Area—2900 square feet (269.4 square meters)

Engine Data—Perkins 105 horsepower diesel

Construction—Burma teak hull and deck plank on steel frames, fastened with insulated phosphor-bronze bolts; oak/teak interior, Canadian spruce spars, polyester sails

Home Port—Saint Thomas, Virgin Islands

Fair Sarae

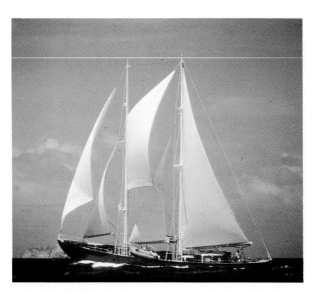

If someone should ask what boat I might willingly take across the mid-winter North Atlantic, the only answer would be **FAIR SARAE**. The voyage would be spent in comfort, too, for this schooner was built to withstand anything from icebergs to old age, and her interior boasts such delights as elm panels cut from London's old Waterloo Bridge. Fortunately, this hypothetical cruise would not require using the schooner's original name, because even the friendliest port might have difficulty welcoming a yacht called **WHITE BITCH**.

The August 6, 1937, *Yachting World* Magazine contained an article which began as follows: "When an owner is sufficient of an individualist to choose a name like **WHITE BITCH** for his yacht, it is almost certain that the yacht herself will be unusual. Mr. Henry S. vom Berge is a cruising man of considerable experience, a skilled navigator, and (perhaps this last should be emphasized) captain of his own ship. Deciding to build a vessel for deep-sea cruising, the owner stipulated that she should be of exceptional strength, capable of taking care of herself and her crew in really heavy weather...." Mr. vom Berge approved a refined version of the schooner-yacht **MABEL TAYLOR**, built in 1931 at Shelbourne, Nova Scotia, for the Grand Banks fishery.

It should be said that vom Berge was nothing less than an American married to an Englishwoman named Jean White, whose dog-owning family he had proposed to honor with the schooner's baptism. The White family objected, of course, so the yacht was instead given the name **JEANRY**, an inoffensive combination of "Jean" and "Henry." After World War II (during which the Royal Navy acquired **JEANRY** and Mr. vom Berge died), the yacht was sold to shipping-tycoon Stavros Niarchos of Greece, who gave her the name **EROS II** and a few modern touches under the direction of Sparkman & Stephens, New York. Then came ownership by the Goulandris family, another Greek line of shipowners.

Despite the yacht's great size, her original interior was the nearly exclusive domain of Mr. and Mrs. vom Berge, whose aft cabin spanned the entire width of the vessel; only one true guest cabin was provided, although the central dining salon has a folding partition to create extra sleeping quarters. Crew accommodations were in the forward third of the yacht, along with the galley, a well-supplied pantry, and a huge refrigerator suitable for freezing whole sheep.

Today, vom Berge's heavy-weather masterpiece is maintained on a selective Caribbean charter schedule by the able Captain Ian Curlewis and is owned by Lucy Bancroft of San Francisco, California, who explains that "Sarae" (pronounced "sah-ray") was a name used for generations in her mother's family. After a long ocean voyage, North Atlantic or not, it's a name to be welcomed in any port.

Designers—William McC. Meek & Sidney Graham
Builder—Brooke Motor Craft Company; Lowestoft, England (launched 1937)
Length—103 feet (31.39 meters) overall; 79 feet (24.08 meters) at waterline
Beam maximum—21 feet 9 inches (6.63 meters)
Draft—12 feet 6 inches (3.81 meters)
Displacement—396,720 pounds (180,000 kilograms)
Total Sail Area—3800 square feet (353 square meters)
Engine Data—twin GMC diesels, 170 horsepower each
Construction—Burma teak fastened with insulated phosphor-bronze bolts on steel frames and deckbeams, teak keel; elm and teak interior, spruce spars, polyester sails (original sails were heavy vertical-cut Egyptian cotton)
Home Port—Saint Thomas, Virgin Islands

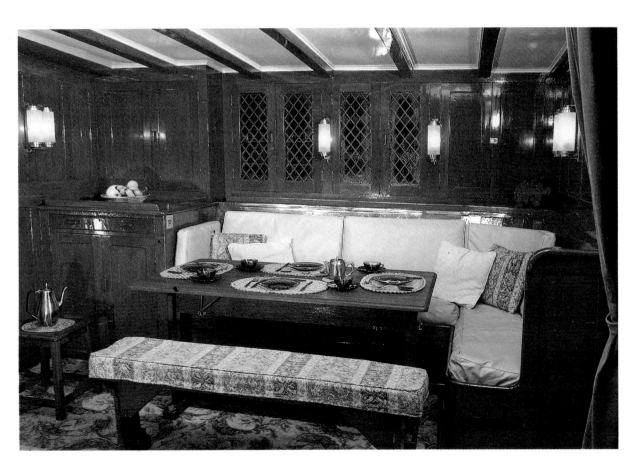

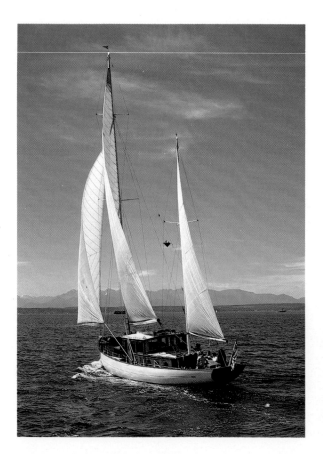

Navita

Some boats lead a charmed existence. Not only was **NAVITA** designed for Claire Egtvedt, a former president of the Boeing Airplane Company, but this motorsailer was built in Seattle, Washington, in the middle of labor negotiations with Egtvedt's own employees. Had the angry Boeing workers, while organizing a union, heard that the company president was planning such an expensive vessel during the Depression, **NAVITA** might never have been built.

Boeing got a union, but Egtvedt also got **NAVITA**. The yacht (whose Spanish name means "little sailor") had troubles ahead: during a foggy passage in 1940 through the San Juan Islands, the ketch ran aground and sank, but Egtvedt and passengers got off safely, and the yacht was salvaged. The year 1968 was even more hectic; **NAVITA** had by then "fallen into the hands of Californians" (a phrase sometimes heard in Seattle) and was caught in a famous smuggling incident by Canadian authorities.

For better or worse, the man who bought **NAVITA** at subsequent auction didn't intend anything more devious than smuggling his grandchildren (even great-grandchildren) on the occasional cruise. Herb Carroll, the owner of a Seattle jewelry store, now devotes most of his time to restoring **NAVITA**'s former glory. Luckily, that's just repair work, for all the original equipment survived, including a huge variable-pitch propeller, the classic Buda engine, and the complete operating manual drawn up during Egtvedt's ownership. The unchanged engine compartment lies under the enclosed wheelhouse and divides the boat into a forward dining salon, with guest bunks and adjoining galley, and an aft owner's cabin with separate bathroom.

NAVITA's charmed existence had a lot to do with the original construction by Norman Blanchard, who emphasized using appropriate types of well-seasoned wood in various parts of the yacht's hull and only a very hard, nonporous teak for the elegant interior; in later years, the boat was carefully rebuilt in Blanchard's yard after each set of hard knocks.

A strange coincidence happened the day the accompanying photographs were taken. While vainly trying with a tiny dinghy to pursue **NAVITA** sailing through a stiff breeze, the photographer was offered a far more stable platform by the gracious captain of a passing motoryacht. After explaining that he had helped to build **NAVITA** but hadn't seen her out sailing in years, the captain introduced himself as Norman Blanchard, Junior, adding, "Too bad **NAVITA** was such a hush-hush project. We were real proud of that one."

Designer—Walter D. Lynch

Builder—Blanchard Boat Yard; Seattle, Washington (launched 1938)

Length—64 feet (19.51 meters) overall; 48 feet (14.63 meters) at waterline

Beam Maximum—13 feet 6 inches (4.11 meters)

Draft—6 feet 4 inches (1.93 meters)

Displacement—61,712 pounds (28,000 kilograms)

Total Sail Area—1236 square feet (114.8 square meters)

Engine Data—150 horsepower Buda-Lanova "Silver Crown" diesel

Construction—Port Orford cedar on oak frames, Alaska cedar stringers, teak keel, bronze-fastened; canvased cedar cabin-top, teak deck on oak beams; teak interior, spruce spars, polyester sails

Home Port—Seattle, Washington, U.S.A.

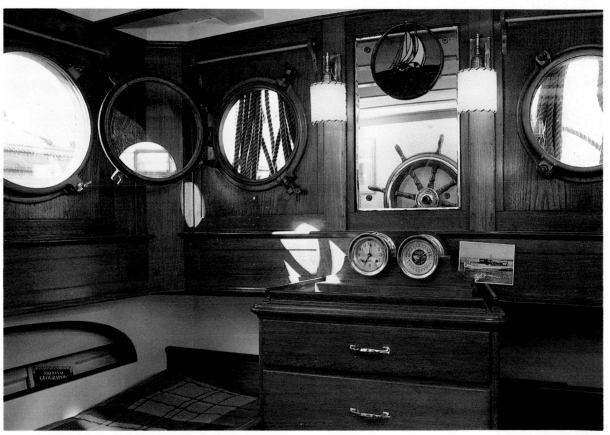

Zivio!

When Mitchel J. Valicenti wants to relax after summertime work in his Wall Street law-firm, he and his wife Mary drive from New York to Rhode Island and spend a cool weekend overlooking Newport Harbor. After arrival, the Valicentis often take no more than a few minutes to unpack, and only a short stroll down their dock soon has them aboard a very soothing yacht.

ZIVIO! is a forty-two-foot yawl of American design, German construction, and rather expensive professional maintenance. Her name comes from a Yugoslav greeting which translates more or less into "all the love you can endure," and her arrival into a new anchorage feels like a movie-star strutting past a row of chorus girls—she steals the show.

The fast and fancy **ZIVIO!** combines traditional materials, an extremely detailed Old World interior and modern performance. At the time of her construction, such features as her raised central cockpit, separating an aft owner's cabin from the main salon, or the "reverse transom" panel facing upwards at the stern were also considered somewhat revolutionary in a yacht of this size.

This cruiser had two designers; the hull and rig were the work of Robert Henry of Annapolis, Maryland, while the general interior layout was designed by David Cluett of Greenwich, Connecticut. Cluett had intended to import and sell an entire series (the "International 800") of luxury vessels identical to his personal racing yacht, but temporary business problems ended the idea, forcing him to sell the prototype. Before making the actual purchase, Valicenti asked a client from his New

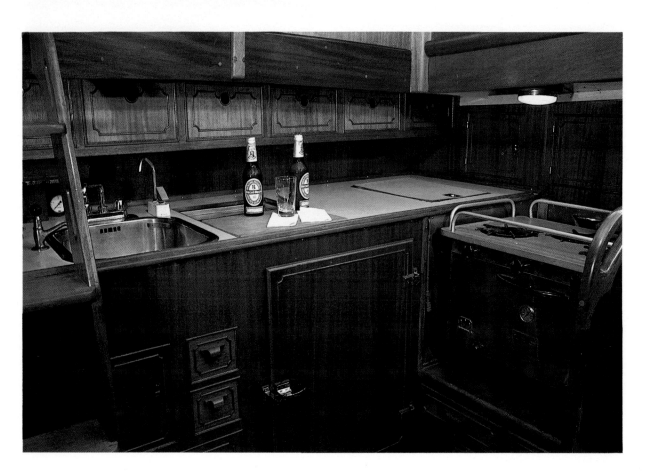

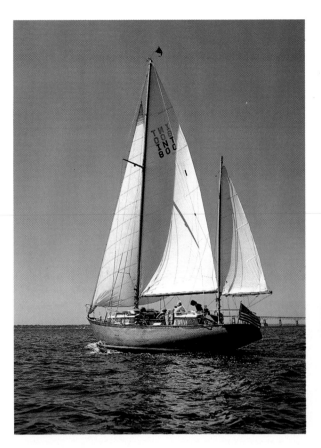

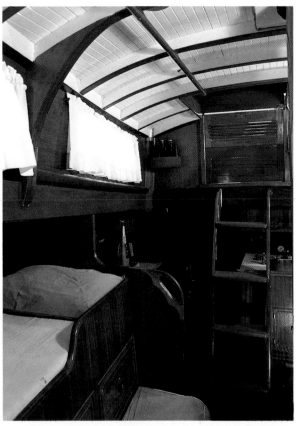

York practice to look at the boat and to recommend a good marine surveyor; that client happened to be Cornelius Shields, one of the most famous men in American yachting, and his approximate words upon inspecting the future **ZIVIO!** were, "To hell with the surveyor. Grab this vessel and run."

It's always fun to watch new sailors aboard this yawl, especially those visitors who ask, "How often does this old wood boat need her bilgewater pumped?" With a twinkle in his eye, Valicenti will interrupt his praise for "any sailboat this size which can be handled by a couple in their seventies," and then he'll lift a floorboard, point into the bilge, and say, "No pumping necessary. I just vacuum once in a while."

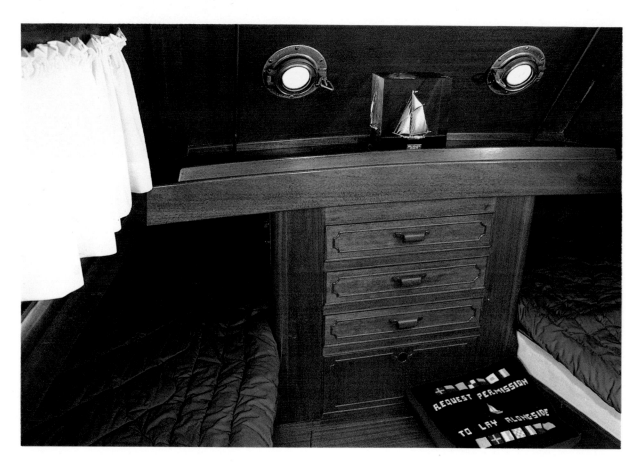

Designers—Robert Henry, David Cluett

Builder—DeDood & Sohn; Bremen, Germany (built 1963, shipped to Nassau and launched 1964)

Length—42 feet (12.8 meters) overall; 30 feet (9.14 meters) at waterline

Beam Maximum—11 feet 10 inches (3.61 meters)

Draft—6 feet (1.83 meters)

Displacement—25,525 pounds (11,581 kilograms)

Total Sail Area—820 square feet (76.18 square meters)

Engine Data—50 horsepower Perkins diesel

Construction—double planked African mahogany on white oak frames, bronze-fastened; teak decks, canvased cabin top, mahogany interior; spruce spars, polyester sails

Home Ports—Saugatuck, Connecticut, and Newport, Rhode Island, U.S.A.

Groote Beer

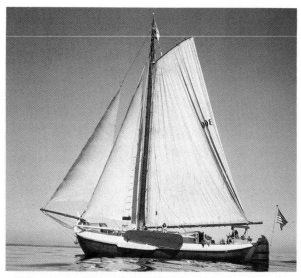

It's strange how legends begin. One version has it that, during the occupation of Holland in World War II, the infamous Hermann Goering ordered the building of the "botterjacht" **GROOTE BEER** for his personal use. Others maintain that Hitler's Air Marshal, skilled though he was in aerial affairs, couldn't have navigated a rowboat and simply tried to confiscate **GROOTE BEER** upon hearing of her design. Finally, the most conservative story says that the vessel was commissioned by an unknown, but obviously inspired, minor officer of the Third Reich, his name now lost to history.

One part of the legend seems beyond doubt, and it's a twist that boatbuilders especially will enjoy. During **GROOTE BEER**'s construction, it became apparent to the shipwrights handling the job that what this un-

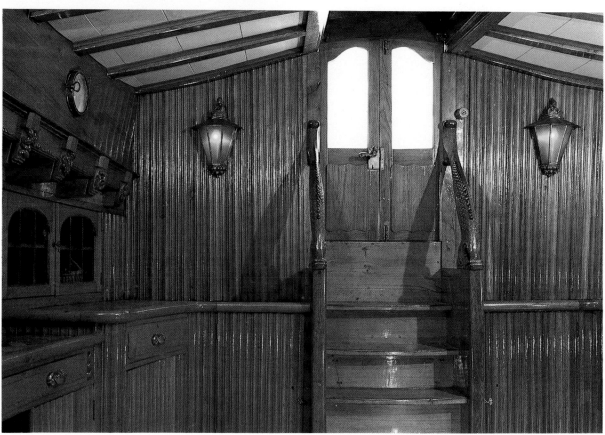

usually large yacht really needed was a certain "careful attention to detail," an approach traditionally reserved for only the most special (and troublesome) clients. Realizing also that forced-labor camps awaited any unlucky civilians whose normal duties had been fulfilled, the old men employed aboard **GROOTE BEER** used all the generations of acquired skill at their disposal: no time or effort was spared in making the boat's hull as strong as possible, and every conceivable cabinetmaker's trick went into the below-decks joinery. When it all seemed just about finished, those old men insisted upon going back and embellishing their earlier work, carving even the yacht's basic structure, varnishing and polishing away the years.

The result, of course, was that **GROOTE BEER** was never delivered to anybody, not even Goering. When World War II ended, the boat was sold at auction, going first to the Hague, then across the Atlantic to Florida, and finally around to the Pacific Ocean side of North America. As indicative of her strength, which derives from her cargo-hauling ancestors, **GROOTE BEER** has in her lifetime survived a hurricane and tidal wave, but her true value is as a floating monument to master-carver Anton Fortuyn of Laren, the Netherlands.

Stuart Anderson, owner of the "Black Angus" and "Cattle Company" restaurants in the U.S.A. and Canada, now keeps **GROOTE BEER** in Seattle, Washington. He points out that the boat's name translates to "Great Bear" (Ursa Major), the proper name for the Big Dipper constellation; he is proud that, despite continuous improvements to **GROOTE BEER**'s accommodations and electrical equipment through the years, all of her original Old World interior remains, including the woodburning fireplace of marble and Delft tile, the leaded-glass cabinet windows, and the varnished counters of woven wood strips.

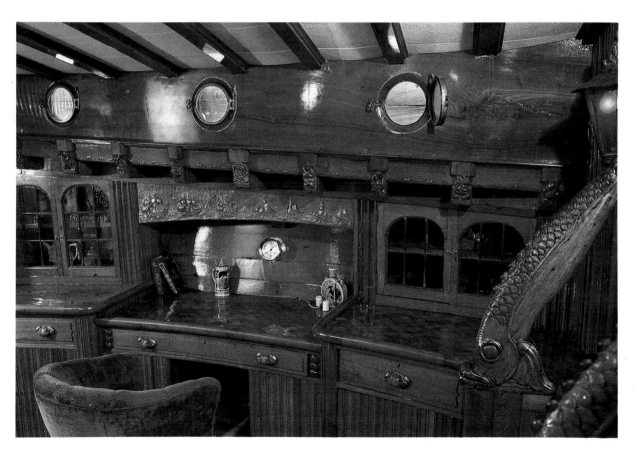

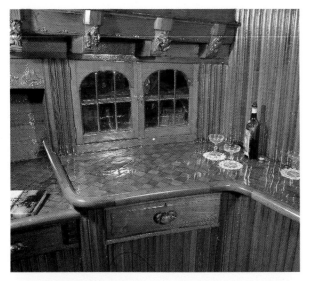

The yacht's barge-like hull is much larger than the normal botterjacht type upon which the design was based. Because the wide interior provides standing headroom right out to the farthest corners, the overall effect is not unlike being in a very comfortable house, especially because of the thick wall-to-wall carpet in all the cabins. One modern installation has been a complete ventilating system, which not only benefits **GROOTE BEER**'s human occupants, but also keeps a traditional wooden hull free from dry-rot bacteria.

Whoever did in fact order **GROOTE BEER**'s construction, he could not have foreseen her magical effect on children. Having sailed only aboard today's boats of fiberglass and plywood, one little boy emerged on deck after a tour of **GROOTE BEER**'s cabins and stood speechless, as if paralyzed by a thought too complex for mere words. Asked his opinion of the boat's interior, the boy turned to his mother and answered, "It's like the castle—the castle in my dreams."

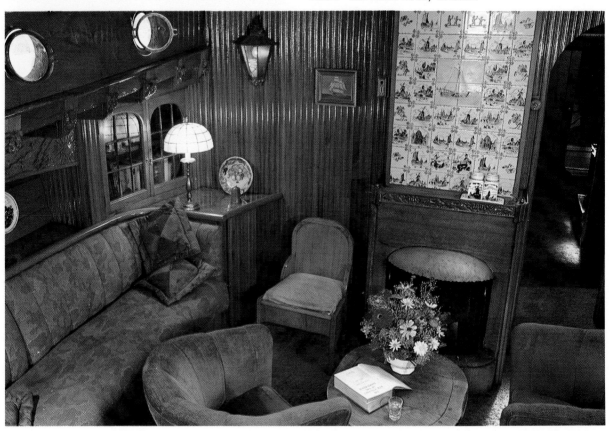

Designer/Builder—traditional North Sea botterjacht by J. Kok Shipyard, Huizen, Netherlands (built 1941–1945); interior later completed by H.W. DeVoogt & Zoon, Haarlem

Length—67 feet (20.43 meters) overall; 52 feet 6 inches (16.0 meters) on deck; 44 feet 8 inches (13.61 meters) at waterline

Beam Maximum—18 feet 2 inches (5.54 meters)

Draft—4 feet (1.22 meters); 10 feet (3.05 meters) leeboards down

Displacement—83,752 pounds (38,000 kilograms)

Total Sail Area—1829 square feet (170 square meters)

Engine Data—Perkins 80 horsepower diesel

Construction—double oak plank over oak frames and keel, iron-fastened; teak/oak deck and interior; pine spars, polyester sails

Home Port—Seattle, Washington, U.S.A.

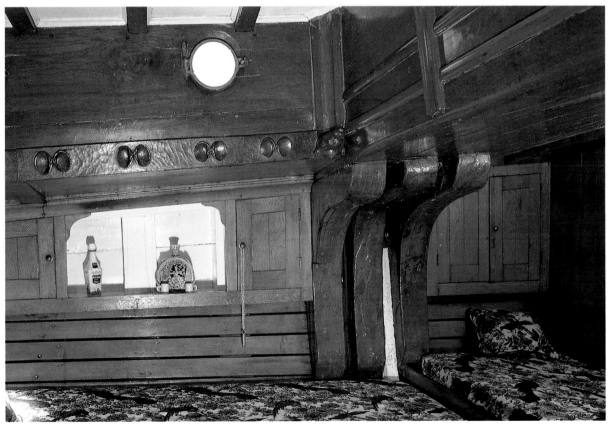

Dauntless

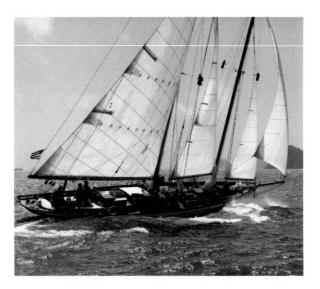

The famous John Alden, who designed this schooner for a Mr. E.B. Entwisle, might spin in his grave at the thought of so much voluptuous red velvet, but anyone with the slightest sense of humor will appreciate the careful planning of owners Richard and Betty Jean Williams. For one thing, all that deep carpeting, wallpaper, and paint don't affect the boat's basic structure, and that structure has fared very well indeed; before **DAUNTLESS** was sailed from Florida to California, her previous owners had already spent nearly $200,000 overhauling the boat's planking, frames, and fastenings, and then the Williams' budget allowed for $60,000 worth of continued restoration. The most ambitious project was the installation of a new cockpit, courtesy of local builder John Owens. After that came the cosmetics: a new mahogany/brass dining table (with navigation-chart drawer), stained-glass cabinet windows, an antique woodstove in bright red enamel, and a set of custom-made tulip lamps.

Paul Johnson has been skipper aboard **DAUNTLESS** since before her purchase by Williams in 1977 and recalls that the boat once carried the names **CHISHAZA** and **GRACE**, the latter to honor a previous owner's connection with the Grace Steamship Company. Johnson grew up sailing scows on White Bear Lake in Minnesota, but in the few years during which **DAUNTLESS** has been his home, he has seen almost twenty thousand miles of ocean sailing, visiting the Caribbean, the coasts of Florida, Mexico and South America. Although there are times when he complains about the maintenance required on a big wooden yacht, he claims that, unlike modern boats designed primarily to fit a rating-rule, **DAUNTLESS** was simply made beautiful, fast, and seaworthy, and she actually appreciates in value as the years go by.

But how does Johnson feel about that outrageously red decor? He's a quiet and gentlemanly sort, and he admits that he would set up his own boat just a touch more conservatively, but he laughs off criticism of the Williams' den of iniquity.

Designer—John Alden

Builder—Dauntless Shipyard; Essex, Connecticut (launched 1930)

Length—74 feet (22.56 meters) overall; 61 feet (18.59 meters) on deck; 43 feet 3 inches (13.18 meters) at waterline

Beam Maximum—13 feet 4 inches (4.06 meters)

Draft—9 feet (2.74 meters)

Displacement—55,100 pounds (25,000 kilograms)

Total Sail Area—2200 square feet (204.4 square meters) without "fisherman topsail"

Engine Data—85 horsepower Perkins diesel

Construction—double Honduras mahogany plank, bronze-fastened on steam-bent oak frames; teak decks over oak beams; mahogany interior, hollow fir spars, polyester sails

Home Port—Oakland, California, U.S.A.

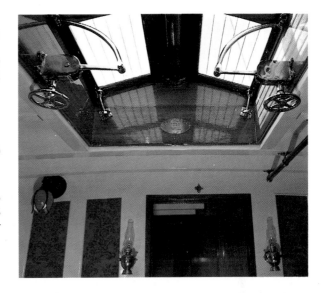

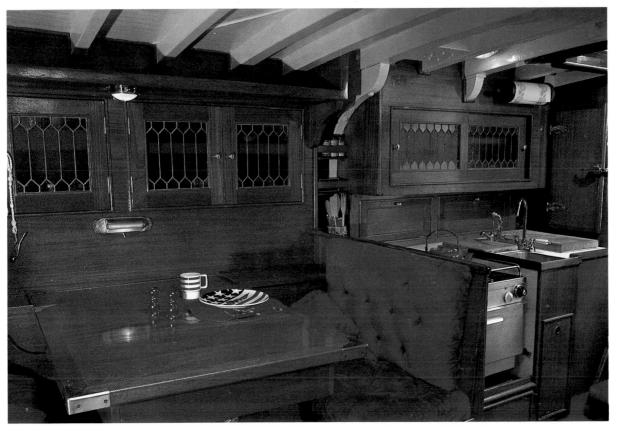

Xebec

While most people spend their lives meekly accepting what they're given, buying what they're told, and trying out every passing fad, a very special few seek out and preserve something quite rare—beauty. Edward and Jacqueline Ogley are among that special minority. What they have chosen to preserve, a 115-foot turn-of-the-century steam yacht, offers a glimpse into a forgotten era at sea, back to the years when "yachting" meant brass-buttoned uniforms, white gloves, and banquets with the Queen.

What is difficult to believe is that, when not actively operating **XEBEC** for charter guests, the Ogleys have been living aboard and restoring their vessel without benefit of any great wealth. The huge untaxed fortunes so common during England's Industrial Revolution may have launched scores of clipper-bow, coal-burning yachts like **XEBEC**, but it's not money that keeps her afloat today. It's work.

If pressed on the subject, Captain Ogley would list his normal occupation as a "yacht and ship surveyor," and he would therefore point with some authority to **XEBEC**'s hull of now-priceless Burma teak as the main source of her longevity. Had the yacht been built of iron or steel, as were so many others launched just before The Great War, by now she might have some very rusty plates in need of replacement (assuming the entire hull hadn't been snatched along the way as wartime scrap metal). However, all this modest talk of teak hulls would not do justice to **XEBEC**'s owners.

Whatever her familiarity with sandy beaches, bathing suits, and the casual Caribbean life, Jacqueline Ogley still carries a New Yorker's sophistication. Even if **XEBEC**'s salon table is covered at some chance moment with tools and children's toys, Mrs. Ogley can nevertheless surprise the visitor by transforming chaos into order: a formal

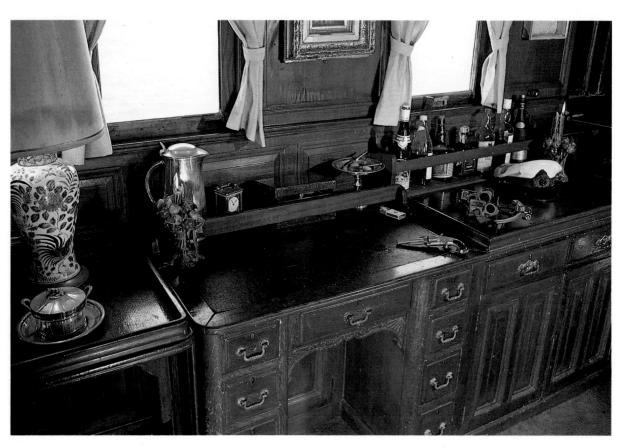

dinner setting for six, complete with background music, vintage wine and heirloom silver.

Edward Ogley is likewise not just a marine surveyor. Now holding an Unlimited Master's License for operation of sail-, steam-, and oil-powered vessels, and once a captain in the Merchant Marine during World War II, his familiarity with **XEBEC** ranges from bridge to bilge and beyond. When it's time to scrub her bottom, he avoids the expense of hauling out (few neighboring boatyards can accommodate **XEBEC**) by diving into the clear Caribbean waters and scraping off seaweed; then, while mindful of sharks, barracuda, and how the Royal Navy did it, the Captain nails up new copper sheathing!

It might be that good taste runs in the family, for Captain Ogley's brother lives in and offers to the public some equally splendid lodgings: the 107-room Drumtochty Castle in Auchenblae-Laurencekirk, Kincardineshire, Scotland. For that matter, their father chose to learn sailing aboard Cape Horn clipper-ships and once served with the legendary Lawrence of Arabia. In any case, whether hearing of **XEBEC** from an old *Playboy Magazine* article or from waterfront gossip, virtually every maritime museum in the world would consider itself blessed to find such a lovely vessel at its doorstep; before that could happen, the museum staff would need to learn, perhaps from **XEBEC**'s present owners, a real appreciation for beauty.

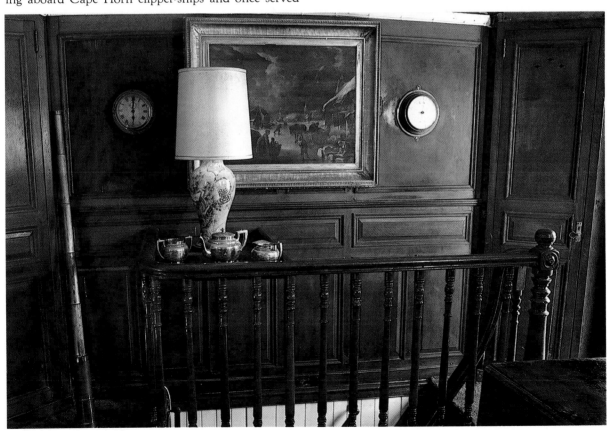

Designer—Charles Nicholson

Builder—Camper & Nicholson, Ltd.; Gosport, England (launched 1900 as **MADELINE**, later renamed **URSULA**, **ALFREDA**, and **XEBEC III**)

Length—125 feet (38.1 meters) overall; 115 feet (35.05 meters) on deck; 98 feet (29.87 meters) at waterline

Beam Maximum—18 feet (5.49 meters)

Draft—9 feet 6 inches (2.9 meters)

Displacement—440,800 pounds (200,000 kilograms)

Engine Data—Gleniffer 160 horsepower diesel (originally held a two-cylinder, coal-fired steam engine and 1000 square feet of auxiliary sail)

Construction—Burma teak (seasoned 80 years) on English oak, bronze-riveted; teak-over-pitchpine deck on oak beams; teak/oak interior

Home Port—Tortola, Virgin Islands

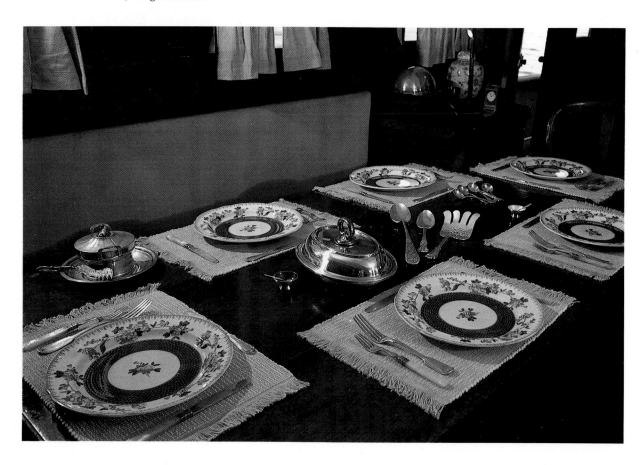

Javeline

As a Director of Allen Organ Studios (London), Ltd., one of the skills acquired by Emyr W. Davies has been the careful judgment of pianos and other keyboard instruments. Just as he knows when highly polished wood is merely hiding poor musical quality, Davies can also sense a fine old instrument under its years of oil and dust, and that detective skill may have helped in the purchase of **JAVELINE**.

The yacht-brokers who advertised this gaff ketch had many other vessels to offer, but Davies was attracted to **JAVELINE**'s classic rig and proportions, enough so that he doubted the specifications in the brokers' survey. Research quickly proved that the yacht had been built, not in the year 1920, but in 1897—rather a tribute to the longevity of **JAVELINE**'s teak construction. However, Davies knew that the ketch was not as ready for immediate use as the brokers liked to think, for the mechanical and electrical systems were in urgent need of maintenance, and even the sturdy rig needed tuning up. Interior restoration was largely a matter of removing modern gadgets that had accumulated through the years, but some cabin joinery had been seriously damaged and required expensive replacement. Fortunately, the distinctive brass hardware on doors and cabin panels had survived alterations in the yacht's narrow interior.

Early historical information was completely unavailable. All that was certain was the previous owner's purchase of **JAVELINE** in Barcelona, Spain, in 1971, and that the yacht originally operated without an engine aboard. Davies may spend more time on the sort of research his boat deserves, but planning the future seems more appealing: **JAVELINE** will be registered again in her native Southampton, so sailors there may witness the ketch celebrating her first century afloat.

Designer/Builder—Summers & Payne, Ltd.; Southampton, England (launched as **JAVELIN** in 1897)
Length—25.8 meters (84 feet 7 inches) overall; 22.8 meters (74 feet 10 inches) on deck; 17.0 meters (55 feet 9 inches) at waterline
Beam Maximum—4.5 meters (14 feet 9 inches)
Draft—3.0 meters (9 feet 10 inches)
Displacement—70,000 kilograms (154,280 pounds)
Total Sail Area—288 square meters (3100 square feet)
Engine Data—Kelvin 72 horsepower diesel, with off-center propeller
Construction—teak plank and deck bronze-riveted on oak frames, keel, and deck-beams; mahogany/teak interior, pine spars, polyester sails
Home Port—Cannes, France

Doxa I & Irene

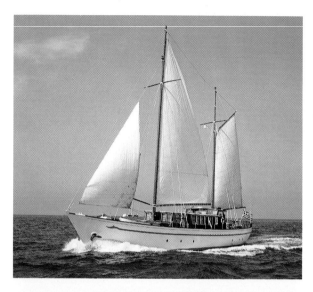

Luxury can interfere with a good time at sea, especially if one pays dearly for it. **DOXA I** and **IRENE** are typical of the semi-traditional motorsailers becoming popular as charter vessels in Greece, for they offer a friendly crew and flexible schedule without costing more than the average Athens hotel; how many hotels can carry you out to the islands, with the sun all yours and the entire Aegean Sea as your swimming pool?

A successful charter vessel often finds that silver tableware and crystal wine glasses really don't impress people who are already accustomed to these things. The most frequent customers prefer to sail tourist class—clean linen, good food, and a comfortable boat. If the charter guests want a fancy restaurant dinner, a brief stop at even the most secluded island will produce all the

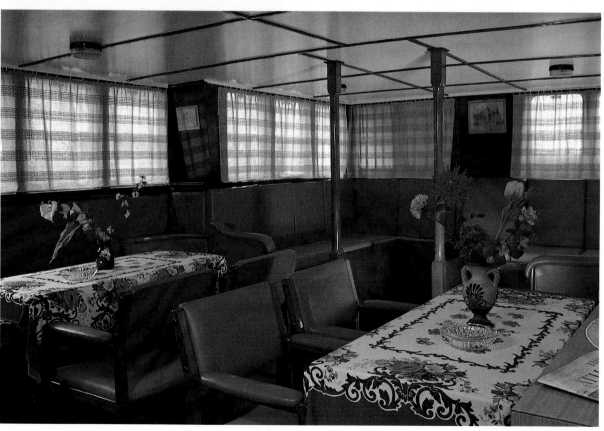

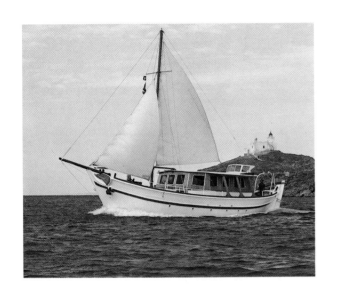

gourmet delicacies one might desire, or special arrangements can be made in advance with the ship's cook.

DOXA I was designed specifically as a charter yacht. She is heavy and stable, which gives up a little speed, but the feeling of security pleases novice sailors, and the added room allows for plentiful accommodations and storage. Two large families or an overseas corporation's most deserving executives can take this ketch on a holiday; in one case, the president and cabinet officers of an oil-rich little nation vacationed modestly aboard **DOXA I**.

The part-owner (with Valef Yachts, Ltd.) and captain of **DOXA I** is Kyriakos Mandilaras, one of five brothers from Syros, in the Cyclades. His twenty-five years at sea includes previous charter work in England and for the "Club Méditerranée" organization, besides experience on tankers and freighters. Before **DOXA I**, Mandilaras and his brothers operated two big charter boats, each called **ESPEROS**, on which began his popular practice of using fish-nets whenever guests want fresh seafood.

IRENE also belongs partly to her captain, Stavros Tsatalios, who shares ownership with an economist at the University of Athens and a Swedish banker residing in Paris. This particular yacht has simpler accommodations and an unpretentious interior, which is only appropriate for a converted working vessel; unlike the relatively modern **DOXA I**, traditional **IRENE** was an authentic "caique perama" sailboat, performing regular ferry service for passengers between the islands of Andros and Rafina. Tsatalios did much of the boat's reconstruction work himself, relies occasionally on his family for help with maintenance, and happily leaves arrangements for **IRENE**'s international guests to the Yacht Charter Center of Piraeus.

DOXA I

Designer—Doxiades Associates, Athens

Builder—G. Psaros Shipyards, Piraeus (launched 1964)

Length—23 meters (75 feet 5 inches) overall; 20 meters (65 feet 7 inches) at waterline

Beam Maximum—5.80 meters (19 feet)

Draft—2.14 meters (7 feet)

Displacement—100,000 kilograms (220,400 pounds)

Sail Area—147.2 square meters (1584 square feet)

Engine Data—Mercedes Benz 265 horsepower diesel

Construction—"pefko" pitchpine, galvanized iron fastened; teak deck, mahogany interior, spruce spars, polyester sails

Home Port—Pasalimani, Piraeus, Greece

IRENE

Designer/Builder—Mavrikos Brothers, Syros (launched 1953)

Length—22 meters (72 feet 2 inches) overall; 19.5 meters (64 feet) on deck; 17.8 meters (58 feet 5 inches) at waterline

Beam Maximum—5.9 meters (19 feet 4 inches)

Draft—2.0 meters (6 feet 7 inches)

Displacement—80,000 kilograms (176,320 pounds)

Sail Area—60 square meters (646 square feet)

Engine Data—Rolls/Royce 165 horsepower diesel

Construction—"pefko" pitchpine, galvanized iron fastened; teak decks, mahogany interior, aluminum spars, polyester sails

Home Port—Pasalimani, Piraeus, Greece

Dulcidry

Giorgio Musso works in La Spezia with the Tarros Corporation, which sends tremendous containerships from Italy to Algeria, Libya, Malta, and Sardinia. It's an unromantic business using his engineer's skills rather than his romantic nature, but when he comes home each day, the view from his window more than compensates for all the paperwork back at the office. Musso, his wife, and three children reside in the coastal town of Lerici, and they sail in some of the most beautiful waters under the Mediterranean sun—blue waters which often lose the correct name "Golfo della Spezia" in favor of "Golfo dei Poeti." Lerici once was home to the poet Lord Byron and his friends, and the last of his frequent swims from Lerici to Portovenere cost Lord Byron his life.

It would take a poet to unravel the word-play involved in naming **DULCIDRY**, so I'll merely say this third

among the Musso yachts was preceded by the first-born **DULCINEA** and subsequent **DULCIDU**. Luca Taddei was asked to design **DULCIDRY** as a so-called "Three/Quarter-Ton" racer with every competitive advantage allowed under the International Offshore Rule, but in one of those fateful twists that give naval architects nightmares, the I.O.R. rating system was altered on the very day **DULCIDRY** was launched. Naturally, the boat's handicap went up, so this lightweight "rule-beater" had to modify her slippery hull shape, or sacrifice sail area, or give up racing altogether. Musso and Taddei made a few subtle changes, but the yacht will not have as much of an advantage as originally hoped.

Of course, in terms of pure speed, **DULCIDRY** is untouchable, especially with her big colorful spinnaker up and pulling. Luca Taddei's creation leaves anything remotely her size far behind, which the Veneziani Paint Company surely anticipated when they offered the new boat a free paint-job using their latest space-age polyurethane varnish. Quite a few Mediterranean sailors have been passed by Musso's shiny wooden yacht, and the first thing they wonder is "What in the devil's name was *that?*"

Designer—Luca Taddei

Builder—Menconi Pietro & Company, Marina di Carrara (launched 1978)

Length—11.0 meters (36 feet 2 inches) overall; 8.10 meters (26 feet 7 inches) at waterline

Beam Maximum—3.65 meters (12 feet)

Draft—1.9 meters (6 feet 3 inches)

Displacement—3400 kilograms (7494 pounds)

Sail Area—62 square meters (667 square feet)

Engine Data—Drofin 12½ horsepower diesel

Construction—okume interior and exterior veneers diagonally laminated with resorcinol glue on cedar core veneers; spruce longitudinals, laminated mahogany keelson, spruce/mahogany frames and deck-beams; welded stainless-steel floors, birch plywood interior; aluminum spars, polyester sails

Home Port—Lerici (La Spezia), Italy

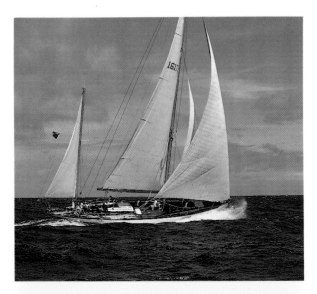

Zorra

A s soon as the Cosmo brothers of Anzio, Italy, finished building **HERITAGE** in 1965, they knew the slender yawl would earn trophies in competition. Designed to the maximum handicap-rating allowed by the Royal Offshore Racing Club, **HERITAGE** was also the result of some very sophisticated boatbuilding, so not many months passed before this yacht was busy collecting Mediterranean silverware.

The glory didn't last long. Racing sailors around the world had adopted the new International Offshore Rule, and **HERITAGE** suddenly became old-fashioned among sailboats boasting radically different bumps and curves. The yawl was returned to the Cosmo yard for some interior changes: another guest cabin on the port side, a new galley arrangement and increased storage for personal gear. Because the same craftsmen who had built

the yacht also made the later changes, the interior did not lose its most striking aspect—the rare mix of efficiency and highly decorative woodworking. After a few years, new owners took the boat into the Caribbean charter business, and yet another proven racer was sent out to pasture by changes in the measurement rules.

Present owners Mr. and Mrs. Paul Taylor don't pay much attention to such rules, however, and it shows both in the lively way they sail and in how they translate their yawl's new name: "Vixen, foxy lady, good-looking chick, take your pick." Having chartered on both sides of the Atlantic, the Taylors today offer a boat with more than just good cooking and a well-stocked liquor cabinet: if the paying guests are game for it, **ZORRA** can hoist a little extra sail-area in a breeze, challenge nearby yachts to a race, and be somewhere over the horizon before those neighbors even respond.

Designer—Illingworth & Primrose; Emsworth, England

Builder—Cantiere Navaltecnica; Anzio, Italy (launched 1965)

Length—73 feet (22.25 meters) overall; 55 feet (16.76 meters) at waterline

Beam Maximum—16 feet (4.88 meters)

Draft—10 feet 3 inches (3.12 meters)

Displacement—85,000 pounds (38,565 kilograms)

Total Sail Area—2500 square feet (232.3 square meters)

Engine Data—Cummins 215 horsepower diesel

Construction—mahogany plank bronze-riveted on acacia frames; teak deck over fiberglassed plywood and laminated mahogany beams; teak/mahogany interior, aluminum masts, spruce booms, polyester sails

Home Port—Saint Thomas, Virgin Islands

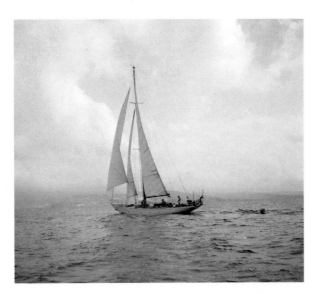

Sirocco

Movie-star Errol Flynn played his share of celluloid pirates and sheiks, and audiences were always amazed by his devil-may-care air of danger. If the cabin walls in his old **SIROCCO** could talk, however, more people would know that Flynn's real life wasn't quite so careless, for he was perhaps the ultimate example of a sex symbol trapped by his self-created reputation. In the end, his life having become a drunken torment without family or friends, he often blamed it all on that one night aboard **SIROCCO**—the night he fell into the tenderest trap of all.

The details are in the book *Bring On The Empty Horses*, written by David Niven, Flynn's suave partner on the Silver Screen. Claiming to have attended one of many wild parties held on **SIROCCO**, a young woman accused Flynn of statutory rape, and the resulting court trial made lurid newspaper headlines immediately. The defendant's lawyers supposedly proved that the alleged victim could not have been aboard the ketch on the night in question, but what the judge and jury thought didn't matter to the general public, because Flynn found himself branded a love-'em-and-leave-them wolf whether he liked it or not. His marriage was destroyed, his finances quickly fell apart, and the phrase "in like Flynn" soon came to mean more than just swinging on chandeliers; that phrase haunted the actor for the rest of his career.

SIROCCO had been sailed by Flynn from New York to the Caribbean, then through the Panama Canal around to California, where the yacht stayed long after being sold in the early Forties. In 1969, a new owner named Steve Guy began a seven-year circumnavigation with stops in Tahiti, Madagascar, South Africa, and Brazil. During the long cruise, the yacht was completely rebuilt in Whangarei, New Zealand, and her sail-plan changed to simple cutter rig. However, the elegant mahogany bulkheads, salon panels and leaded-glass cabinet windows, which Flynn had carefully maintained, were also preserved during the stay in New Zealand.

Flynn named **SIROCCO** after the hot Sahara wind which sometimes flies across the Mediterranean Sea. All things considered, most sailors prefer the gentle breeze enjoyed by present captain James Steivang during Caribbean charters.

Designer—John Alden

Builder—George Lawley & Son; Neponset, Massachusetts, U.S.A. (launched as **KARENITA** in 1929)

Length—74 feet 9 inches (22.78 meters) overall; 48 feet 9 inches (14.86 meters) at waterline

Beam Maximum—14 feet 11 inches (4.55 meters)

Draft—9 feet 6 inches (2.9 meters)

Displacement—79,344 pounds (36,000 kilograms)

Total Sail Area—2085 square feet (193.7 square meters) cutter rig

Engine Data—Ford/Lehman 105 horsepower diesel

Construction—double Honduras mahogany plank bronze-fastened on oak frames and keel; teak deck on oak beams, mahogany/teak interior; spruce spars, polyester sails

Home Port—Saint Thomas, Virgin Islands

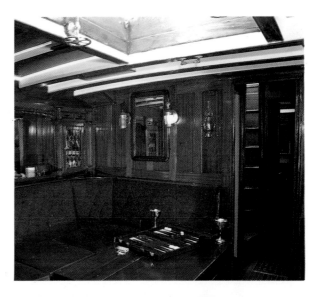

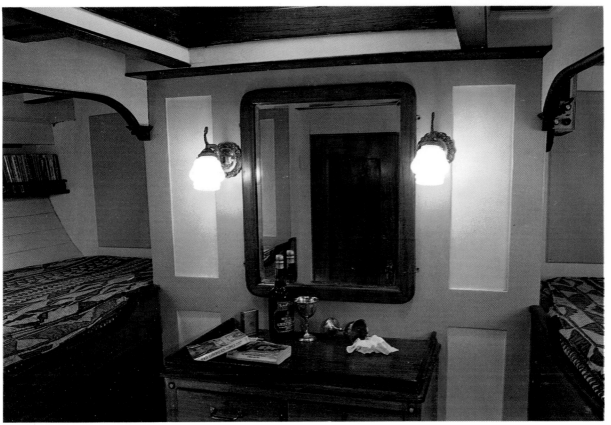

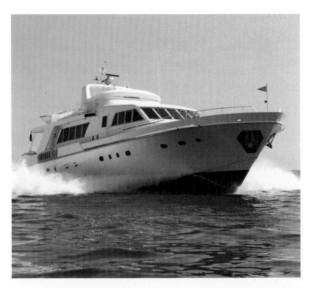

Jacaranda

The most refreshing thing about large high-speed motorboats, aside from all the wind rushing by, is that neither designer nor owner is bothered by any sort of tradition. There are no dusty books on the subject to caution against creativity, and the only rule worth keeping in mind is that, no matter how fast the boat, it must hold together under the punishment.

In fact, many high-performance motoryachts have no more resemblance to normal boats than might the average rocket to Outer Space: modern Italian vessels, especially, would look quite at home floating along in the movie "Star Wars." What bothers the inflexible traditionalist is that yachts like the Spanish **JACARANDA** do indeed perform: the anchor comes up smoothly when one pushes a button, the navigation equipment could almost find gold on a foggy night, and, while the neigh-

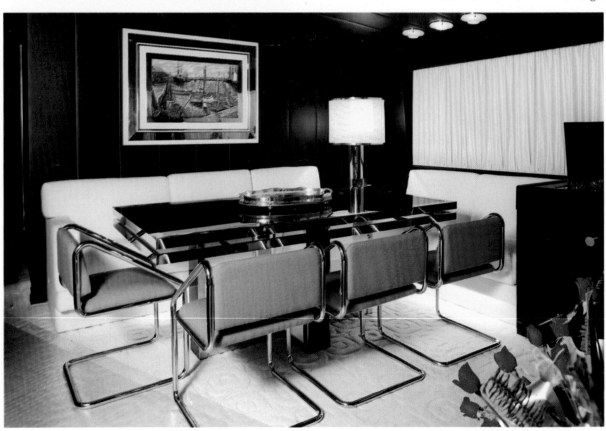

bors are still getting themselves organized, aboard **JACARANDA** one is already flying away at thirty knots.

The builders of **JACARANDA** understand the word *speed*. A good part of their business is the construction of military patrol-boats, which means satisfying some very critical and demanding clients, and Astilleros Viudes also builds pleasure-craft for, among others, the King of Spain, so their experience with pure speed is matched by their highly functional interior design.

Accommodations aboard the delightfully modern **JACARANDA** are virtually abstract in their design, and few cabins have any decoration in the usual sense. Much of the lighting equipment, for example, is blended into the walls or furniture and remains unnoticed until actually in use; even a minor detail such as a door-handle is expected to carry out its task without complicating a room's appearance.

Perhaps to show their wide design capabilities, however, the craftsmen at Astilleros Viudes point out that **JACARANDA**'s owner's son asked for a cabin with the very best traditional woodworking and "classic" design. He got it.

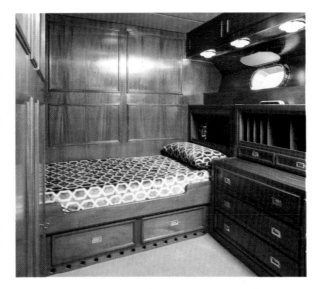

Designer/Builder—Astilleros Viudes, Barcelona
(launched 1975)
Length—23 meters (75 feet 6 inches) overall; 20.5 meters
(67 feet 3 inches) at waterline
Beam maximum—6.12 meters (20 feet 1 inch)
Draft—1.2 meters (3 feet 11 inches)
Displacement—54,000 kilograms (119,016 pounds)
Engine Data—twin MTU diesels, 900 horsepower each
Construction—double diagonal mahogany veneers
bronze-nailed with resorcinol glue over
longitudinal mahogany strip-plank; hull
bottom coated with epoxy resin; laminated
elm and mahogany frames, iroko/ma-
hogany keel; teak deck over fiberglassed
plywood and laminated mahogany/pine
beams; interior of mahogany, waterproof
fabrics, and stainless-steel trim
Home Port—Barcelona, Spain

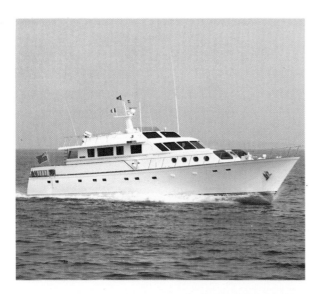

Solaria Too

The beaches of southeastern France offer an unlikely stretch of coastline for a large industrial location, but only a few kilometers to the west of Cannes is where Jean Jolly started building fast motorboats over thirty years ago. Today his company, Chantiers Navals de l'Estérel, is famous throughout the world for the military craft and yachts built in the Cannes yard.

The real surprise, however, is that every vessel launched by Estérel is constructed exclusively of "Sipo close-grain mahogany," some of the most beautiful and durable wood known to boatbuilding. The decision was strictly scientific and is explained in the company's military brochures: laminated mahogany will produce the strongest and most inflexible hull at any given weight—better than steel, better than aluminum. To a

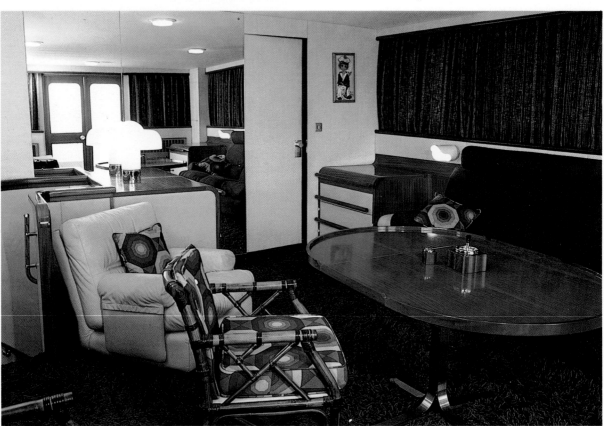

Navy captain involved in coastal patrols, that simply means maximum speed, and to a yacht owner, a lighter boat also means increased fuel-efficiency.

The main difference between Estérel military hulls and their yachts is the interior accommodation provided, because identical construction techniques are used. Had **SOLARIA TOO** been a military contract, the exterior would be painted flat grey, there would be more cabins aboard for the larger crew, and the cabins would be relatively plain; on deck, machine-guns would take the place of soft cushions. The upper limit, by the way, among the company's military craft is a forty-two meter (138 foot) "fast strike boat" capable of an incredible thirty-nine knots even in moderate seas; that vessel comes equipped with a computerized missile-launcher which is able, at a range of several kilometers, to lift uncooperative smugglers entirely out of the water.

Fortunately, **SOLARIA TOO** was designed for more pacific purposes. This magnificent yacht is slightly wider than the lean hulls used for Estérel patrol-boats, which creates greater interior volume, and the propulsion machinery was chosen for better economy instead of extreme speed; the boat is nevertheless capable of twenty-three knots, with a comfortable nineteen knots cruising velocity. Captain Tom Strutton points out that the extended cruising range can take him virtually anywhere in the Mediterranean. He also explains the yacht's intriguing name by stating that the owner (Solaria Investment, Ltd., England) has enjoyed two previous vessels called **SOLARIA** and **SOLARIA II**; the third was whimsically christened Solaria, "too."

Captain Strutton was partially responsible for the yacht's interior design, and he says that most of the lighting fixtures and modern bathroom hardware is of Italian

manufacture, while advanced navigation and communications gear came from the United States. His vessel is kept in perfect condition at all times, but she was a masterpiece the day she was launched—a credit to the builders, thanks to the uncompromising standards set by Jean Jolly.

Designer—André Mauric
Builder—Chantiers Navals de l'Estérel, Cannes
　　　　(launched 1973)
Length—26 meters (85 feet 4 inches) overall; 23.40 meters
　　　　(76 feet 9 inches) at waterline
Beam Maximum—5.80 meters (19 feet)
Draft—1.70 meters (5 feet 7 inches)
Displacement—50,000 kilograms (110,200 pounds)
Engine Data—twin GMC diesels, 595 horsepower each
Construction—double diagonal mahogany veneer bronze-
　　　　nailed with resorcinol glue on longitudinal
　　　　mahogany strip-plank; hull bottom coated
　　　　with epoxy resin; laminated mahogany keel,
　　　　frames, and deck-beams, with mahogany
　　　　plywood bulkheads; teak deck over fiber-
　　　　glassed plywood; interior of Afrormosia,
　　　　mahogany, and waterproof fabrics
Home Port—Antibes, France

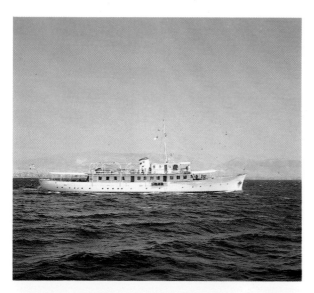

Angela

When William Lefakinis came back to Greece in 1970 after a long stay in the U.S.A., he started Valef Yachts, Ltd., with all the resources he could assemble: one yacht. Eight years later, he had a charter fleet of fifty motoryachts, sailboats, and motorsailers, many of them under his ownership and nearly all of them available with captain, crew, and gourmet cook. The April 24, 1977, issue of *The New York Times* published an article describing the conflict between traditional Greek customs (including the long lunch followed by an even longer afternoon nap) and the need to attract foreign business, so Lefakinis simply reflects an enormous capacity for hard work overcoming an equally enormous love of leisure time.

ANGELA is one of the charter vessels available from Valef Yachts. She was once owned by the late shipping-

tycoon Aristotle Onassis, who gave the yacht as a wedding present to Prince Rainier and Princess Grace of Monaco, all the while secretly hoping that this ostensibly unselfish act would open the principality's gambling to some Onassis ownership. The royal family of Monaco graciously accepted the present and baptized the yacht **DEO JUVANTI** ("God of Youth"); then, to the amusement of everyone save Onassis, Prince Rainier invited the famous Greek to enjoy Monte Carlo's lucrative games of chance just like anyone else—as a paying customer. In 1965, the yacht returned to Greece with the name **DASKA** and new owners: textile-manufacturer Demetrios Sigaras and his wife, pianist Maria Hairogiorgou.

ANGELA's interior has been redecorated several times, but the accommodations plan remains similar to many other yachts of her age and size. The aft end of the main deck, serving as a lounge in warm weather, has a wide entrance into the enclosed main salon, which is then separated from the formal dining-room by the steward's pantry amidships. The galley, crew's quarters and captain's cabin are below deck ahead of the engine room, while all passenger cabins lie under the aft deck and salon. Excluding **ANGELA**'s traditional dining-room, there is little woodwork; cabins are simply bright, easy to clean, and enormous.

Today, **ANGELA** is part of a company that caters to European and Saudi Arabian royalty, Miss Universe festivities, Mick Jagger, and Ted Kennedy. William Lefakinis has gone on to serve as president of the new Hellenic Professional Yachting Association, and he works closely with the National Tourist Organization of Greece. The benefit of all this activity becomes obvious when Lefakinis inspects a Valef yacht just before a charter; when the hard work is finished, he's as willing as anyone else to savor some leisure time.

Designer/Builder—Camper & Nicholson, Ltd.; Southampton, England (launched 1928)

Length—147 feet (44.81 meters) overall; 137 feet 2 inches (41.81 meters) at waterline

Beam Maximum—23 feet (7.01 meters)

Draft—9 feet 9 inches (2.97 meters)

Displacement—714,096 pounds (324,000 kilograms), Thames Measurement Tonnage

Engine Data—two Deutz diesels, 440 horsepower each

Construction—riveted mild steel throughout, teak decks; mahogany/oak/teak interior

Home Port—Marina Zea, Piraeus, Greece

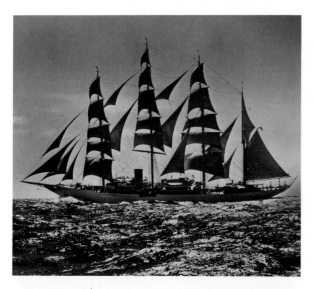

Sea Cloud

T hanks to Captain Hartmut Paschburg and a group of shipowners in Hamburg, the famous **SEA CLOUD** has been made ready for some ordinary charter work. Instead of paying for a hot hotel room and cold restaurant fare, you might consider spending your next vacation with the ocean breeze and banquets aboard this four-masted barque.

Obviously, this charter business would cause pain for **SEA CLOUD**'s original owners. Back in 1931, American stockbroker Edward F. Hutton got married to heiress Marjorie Merriwether Post and thought that a wedding present should celebrate the merger, so he commissioned another black yacht named **HUSSAR**—his fifth. It would be the largest private sailing yacht ever built.

Hutton had the ship constructed in Kiel, Germany, a city always noted for its maritime skills (today's Olympic

sailing events are often held in Kiel Bay), but the million-aire left interior decoration to his bride. After a few round-the-world voyages to entertain the world's dignitaries, the couple divorced and Mrs. Hutton married Wisconsin lawyer Joseph E. Davies. She changed the ship's name to **SEA CLOUD**, and the former "Black Hussar" returned to sea painted pure white; naturally, the glittering gold bathroom-fixtures remained.

In 1937, **SEA CLOUD** went to Leningrad, where Davies had been appointed U.S. Ambassador to the Soviet Union.

Then came World War II service for the U.S. Coast Guard, which stripped **SEA CLOUD** of luxuries and complicated rigging, dropped in some big engines, and sent the ship out for a little submarine-hunting. At war's end, Mrs. Davies complained that **SEA CLOUD** "looked terrible," so the yacht received a splendid new rig and interior. However, the crew's wages and twice-

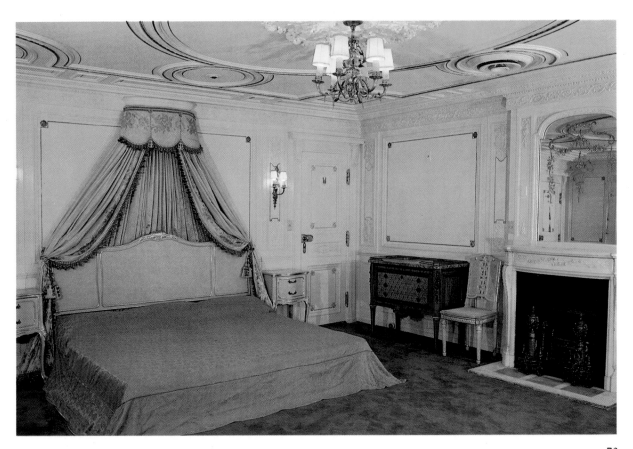

yearly change of uniform (to say nothing of income tax) soon made yacht ownership expensive; when cruises got shorter and the Seamen's Union demands got longer, she sold her ship to General Trujillo, dictator of the Dominican Republic. **SEA CLOUD** was renamed **ANGELITA**.

Trujillo was assassinated in 1961. The new government of the Dominican Republic sold the yacht to a Louisiana businessman, and **ANGELITA** became **PATRIA**. Soon someone else bought the old boat hoping to start a relaxed Caribbean charter business, so **PATRIA** became **ANTARNA**. Eventually, E.F. Hutton's extravagant wedding present found itself tied up in Panama, her future lost amid lawsuits and unpaid taxes. Then Captain Paschburg arrived with the necessary money and experience; he had already managed the sixty-seven-meter schooner **ARIADNE**, so he knew what a big charter yacht involves. However, the new captain's undignified style of recreation might raise a few eyebrows. When his schedule permits, Hartmut Paschburg puts on a bathing-suit and goes cruising aboard the only yacht he really owns, a tiny sailboat which would fit into any one of **SEA CLOUD**'s many cabins.

Designer—Stevens & Cox, New York
Builder—Krupp/Germania Shipyard; Kiel, Germany (launched 1931)
Length—107.5 meters (353 feet) overall; 96 meters (315 meters) on deck; 77.2 meters (253 feet) at waterline
Beam Maximum—14.9 meters (48 feet 11 inches)
Draft—5.0 meters (16 feet 5 inches)
Displacement—3,530,000 kilograms (7,780,120 pounds)
Total Sail Area—3000 square meters (32,280 square feet) without main skysail
Construction—riveted mild steel throughout, teak decks; pine, mahogany, walnut, maple, and marble interior; steel lower masts, Oregon pine upper masts and yards, cotton sails
Engine Data—four Enterprise diesels, 1500 horsepower each
Home Port—Hamburg, Germany

Roseway

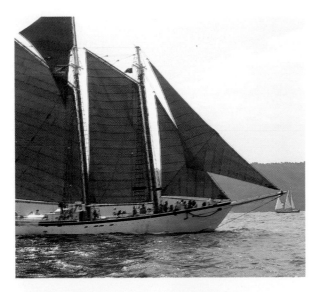

I t's a bit more difficult these days, but back in the 1920s an American millionaire with his heart set on both yachting and a deductible business expense could buy what was called a "yacht-fisherman," sending it to sea periodically to frighten a few cod, but calling it back whenever friends and relatives wanted a cruise. These vessels were almost always "Gloucester-fashion" schooners, and they did in fact have a little room reserved for fish, but their real unprofitable purpose was to provide relaxation for their owners.

They were good boats, however. When a successful lawyer named Hathaway decided that he, too, wanted a yacht-fisherman, he had it designed to be long, fast, and built to last. And last she did. After service as a personal yacht, the schooner **ROSEWAY** was sold in 1941 to the Boston Pilots, who for thirty stormy years following used

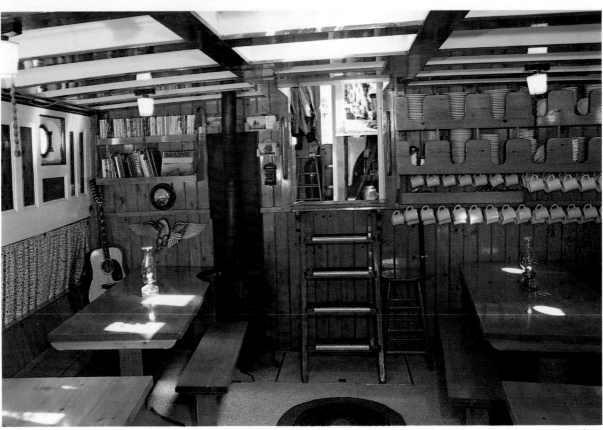

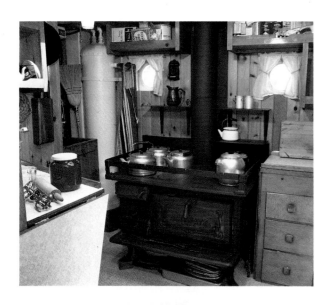

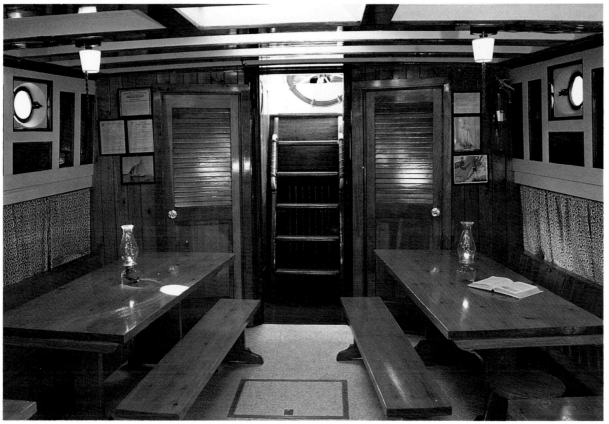

her to guide large ships in and out of Boston Harbor. In 1975, Captain Orvil Young brought **ROSEWAY** to his native Maine, rebuilt portions of her interior and rig, and started her off on yet another career. With his wife Andrea and a hustling crew of young men and women, Captain Young now takes almost forty paying passengers at a time on week-long "Yankee Schooner Cruises" of the Maine coast.

Guests aboard the schooner enjoy the same rustic atmosphere provided by any traditional country inn, but there's an added dimension in **ROSEWAY**'s cabins: the thick oak which forms a gentle curve beside one's bed is in fact part of the schooner's tough hull, and through it, as if in the distance, one can sometimes hear the sea. Many a new sailor finds that the first night's sleep arrives easily, and after the next morning's breakfast in the long knotty-pine dining-room, that first walk on deck is like entering a different century—and perhaps a better one.

One appreciative mother of five, when asked her opinion of a week spent aboard **ROSEWAY**, answered, "We started using all the old sailor words, and I learned to steer the schooner by myself, and my husband said we were having as much fun as rich people, and nobody got seasick, and I didn't even bring along one dress, and besides I ate like a horse and still lost weight. It beats the tail off motels and gas-stations."

So what are you doing next vacation?

Designer/Builder—James Yard; Essex, Massachusetts (launched 1925)
Length—137 feet (41.76 meters) overall; 112 feet (34.14 meters) on deck; 89 feet 5 inches (27.25 meters) at waterline
Beam maximum—25 feet (7.62 meters)
Draft—12 feet 9 inches (3.89 meters)
Displacement—528,960 pounds (240,000 kilograms)
Total Sail Area—5000 square feet (464.5 square meters)
Engine Data—two GMC diesels, 165 horsepower each
Construction—white oak plank on double sawn oak frames, wood "treenail" fastened; pine decks and interior; Douglas fir spars, polyester sails
Home Port—Camden, Maine, U.S.A.

Unicorn

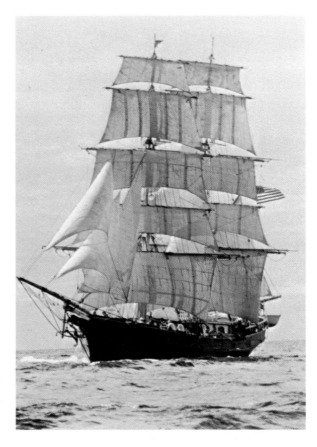

Many owners of well-aged wooden sailboats are satisfied to give the old wrecks a few coats of paint and heavy use as dockside "drinkaboards." Jacques Thiry was different; in 1971, this Franco-American photographer arrived on the coast of Finland, looking for a wooden hull suitable for conversion into a "traditional, square-rigged sailing vessel." What surprised the Finns was that Thiry wasn't rich, he wasn't interested in luxury, and he planned to make the boat earn its living!

Thiry was lucky to find Finnish shipwright Pertti Tarvas, for his help located a ninety-four-foot cargo boat, soon purchased for six thousand dollars. Named **LYRA**, the old schooner had been built after World War II to carry lumber and sand to heavily damaged Finnish cities; after two decades of freight, however, what greeted **LYRA**'s new owners was hardly more than a barge equipped with engine and stump masts.

In 1972, **LYRA** was taken to Sweden, where the deep forests provided new deck and hull planks. Young men and women from the coastal cities of Viken and Ystad then offered to help Tarvas with reconstruction, and Thiry buried himself in research, using plans from the 1867 French brig **ADOLPH & LAURA** to guide the fashioning of spars and traditional iron fittings. To avoid the harsh Scandinavian winter, the newly christened **UNICORN** was taken to England and Spain, then southwest across the Atlantic Ocean to Bermuda.

UNICORN stayed in the Caribbean and South America to haul freight and passengers. Crews came, crews quit, and Thiry became both owner and captain, learning as his ship ghosted from port to sunny port that island commerce is often governed more with bribes, machetes, and machine guns than with written law. Sometimes the brig fought bureaucrats for work-permits, once she was set adrift at night with her anchor line mysteriously cut. There were cargoes of melons, papayas, avocadoes, and pineapples hand loaded from splintered docks and windy beaches. The end came when thirty tons of bananas rotted before delivery, flies and lawsuits filled the air, and Hurricane Fifi wiped out the Honduras coast and Thiry's bank account as well.

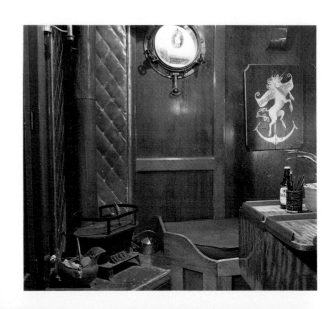

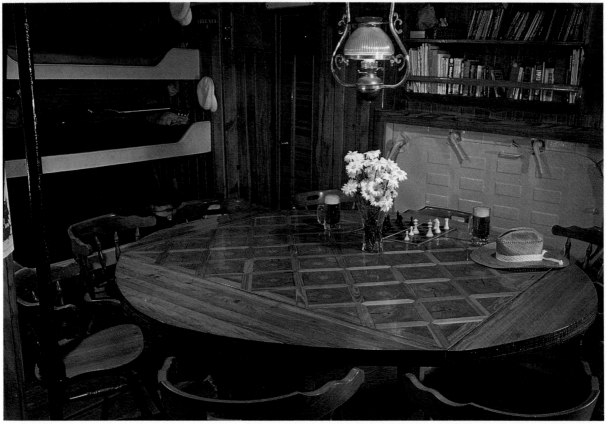

UNICORN sailed to Florida, her finances in sad shape. What saved her was an aging multimillionaire named William W. Smith, who had already rescued the 177-foot Portuguese barquentine **GAZELA PRIMEIRO**. Smith bought **UNICORN** and kept Thiry on as captain, invested seventeen months and one million dollars in the brig's total renovation at Robert Derecktor's Fort Lauderdale boatyard, and yet never lived to see **UNICORN**'s 1976 appearance at "Operation Sail" in New York.

Thiry and **UNICORN** went separate ways. Today the brig is owned by the non-profit Unicorn Maritime Institute of Tampa, Florida; she is an inspected and licensed charter vessel, with an interior designed simply to carry large groups and a professional crew, and she even appeared in the movie "Roots" and television commercials for "Asahi" Japanese beer. Most importantly, hundreds of young trainees learn old-time seamanship aboard her, simply because their parents and teachers understand what Smith, Tarvas, and Jacques Thiry were hoping to preserve. **UNICORN** isn't making anyone rich, but now she earns her living.

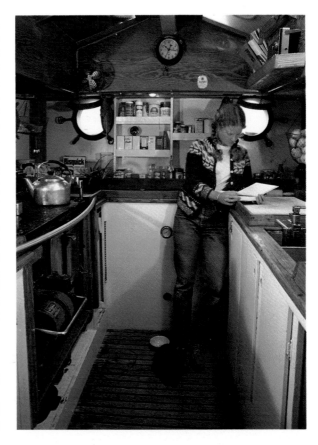

Designer/Builder—Helge Johansson; Sibbo, Finland (launched in 1948)
Length—136 feet (41.45 meters) overall; 96 feet (29.26 meters) on deck; 88 feet (26.82 meters) at waterline
Beam Maximum—24 feet (7.31 meters)
Draft—9 feet 6 inches (2.9 meters)
Displacement—551,000 pounds (250,000 kilograms)
Sail Area—squaresails, 2921 square feet (271 square meters); fore/aft sails, 2211 square feet (205 square meters); studding sails, 2230 square feet (207 square meters)
Engine Data—Caterpillar 335 horsepower diesel
Construction—pine plank, larch keel and frames, iron-fastened; new fir deck and beams; interior yellow pine, mahogany, and redwood; steel lower mainmast, spruce spars, flax sails
Home Port—Tampa, Florida, U.S.A.

Clearwater

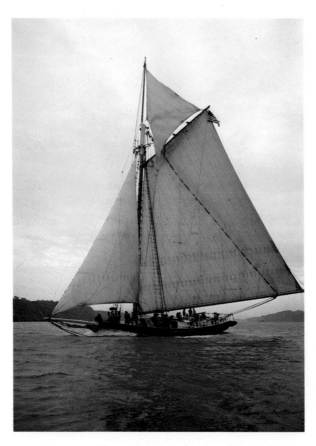

Between the American Revolution and the Civil War, most of the freight and passengers moving on New York's long, beautiful Hudson River traveled aboard the famous River Sloops, powerful vessels roughly one hundred feet in overall length and carrying five thousand square feet of sail. The sloop captains, important men in their agricultural valley, were likewise a thoroughly colorful bunch, given to singing, dancing, and shooting each other (during the occasional informal race). While hauling hay, bricks, butter, and the mayor's daughter on her first journey to The Big City, the sloop crews also had to master the deadly, downwind "Hudson River Jibe": swinging the mainsail and its awesome seventy-foot boom from one side of the boat to the other, a maneuver that once, when the tangled mainsheet wrapped around his neck, caused a careless sailor to lose his head.

CLEARWATER keeps these memories alive, but she is no museum exhibit. Every year, thousands of school-children sail aboard this modern sloop replica and learn about marine ecology, weather, and how to prevent water pollution, and it's a rare riverside festival that doesn't have the boat in attendance, complete with guided tours, home cooking, and even homemade music.

CLEARWATER's professional and volunteer crew members have accommodations in the wide stern of the vessel, which centers around a communal oak dining-table with overhead skylight. Little has been done to

hide or overly decorate the sloop's structural members, so the visitor immediately feels at home—especially on chilly evenings when everyone aboard gathers around guitars and hot apple cider.

Of the organization whose very purpose he helped to inspire, folksinger Pete Seeger once said, "The members of the Hudson River Sloop Restoration are a varied lot—conservative oldsters, bearded students, youths from the ghetto, farmers, teachers, housewives and teenagers, and small-town merchants. They probably disagree on a thousand things, but they're united in one idea: to sail a beautiful boat from town to town, to help their fellow citizens learn to love their river again."

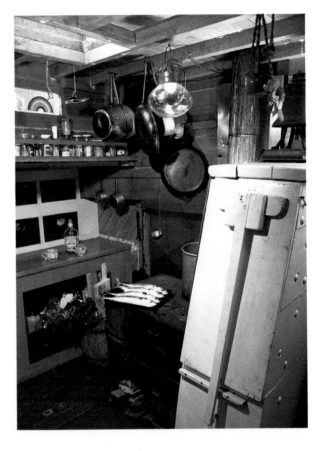

Designer—Cyrus Hamlin
Builder—Harvey Gamage Shipyard; South Bristol, Maine (launched 1969)
Length—106 feet (32.31 meters) overall; 76 feet (23.16 meters) on deck; 65 feet (19.81 meters) at waterline
Beam Maximum—25 feet (7.62 meters)
Draft—8 feet (2.44 meters); 14 feet (4.27 meters) centerboard down
Displacement—218,000 pounds (98,907 kilograms)
Total Sail Area—4305 square feet (400 square meters)
Engine Data—190 horsepower Cummins diesel
Construction—oak frames and oak plank below waterline, fir plank above waterline; Douglas fir spars, polyester sails
Home Port—Poughkeepsie, New York, U.S.A.

Lindø

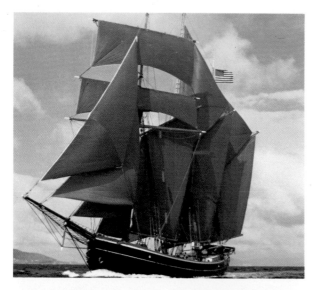

"**B**uilt like a Baltic Trader" is an expression occasionally heard in old boatshops, often over morning coffee by a warm woodburning stove, and it generally refers to the construction of wooden ships, specifically ships built for hard work.

Few Baltic Traders have worked as hard as **LINDØ**. Between her launch and her last cargo run in 1969, this topsail schooner made forty-three crossings of the Atlantic Ocean, carrying lumber, salted fish, grain, and nearly everything else in the way of bulk freight. She visited Nova Scotia, Central America, Iceland, and Spain; and even before her reconstruction in 1970, she could easily have kept on hauling cargo.

In 1976, **LINDØ** represented Denmark in the Operation Sail "Tall Ship Races" and the United States' Bicentennial celebration in New York Harbor. Besides

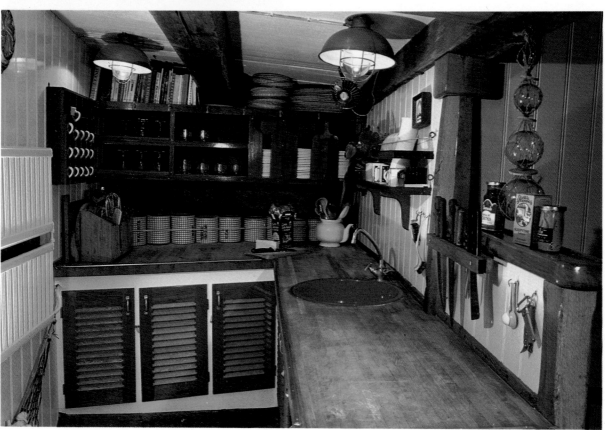

winning an overall third place in Operation Sail's Transatlantic Races, **LINDØ** had a rare rendezvous in New York with her old sister-ship **GEFION**, along with a more fateful visit from two American veterinarians: Dr. William Hardy, Jr., and Dr. Anthony Palminteri.

Hardy and Palminteri simply like to sail, and they purchased **LINDØ** as a business venture. After incorporating the Atlantic Schooner Association, the partners sent their vessel down to the Caribbean, where she's now a favorite in the charter trade. Part of her charm derives from luxury accommodations installed without sacrificing the natural, unfinished appearance of the cargohold's immense oak beams.

But it's still hard work. **LINDØ** often comes in for a twenty-four-hour "turnaround," unloading the old charter guests, refueling, filling up water-tanks, conducting urgent maintenance, catching up on the mail, shopping for a ton of groceries, doing laundry, loading up the new charter guests, and heading out to sea again. Once

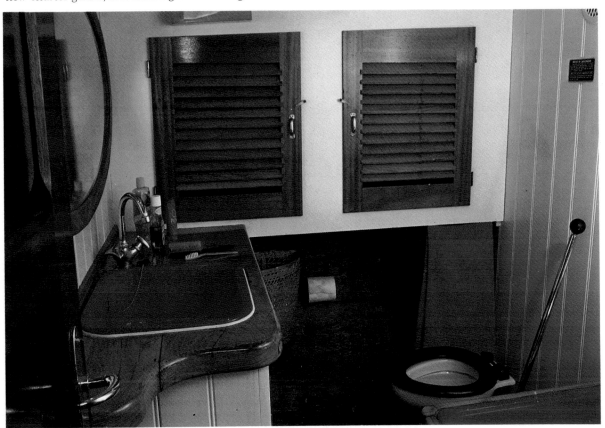

in a while the crew even has time for some genuine shore leave, perhaps cocktails and dinner.

The captain in charge of this schedule is a soft-spoken Tasmanian named Chris Blackwell. Having spent early years aboard **DEFENDER**, an old ketch hauling lumber, and later aboard fishing vessels, Blackwell went on to start a boatyard in Port Sorell, Tasmania, and to study at the Anglia Marine Boatbuilding Center in England, where he learned traditional "lapstrake" construction. Along with that came a tour of Europe to observe work at established boatyards. Blackwell speaks kindly of **LINDØ**'s present owners, who spend nearly as much on the schooner's proper maintenance as is earned from charter work. He also praises his experienced crew, many of whom are women.

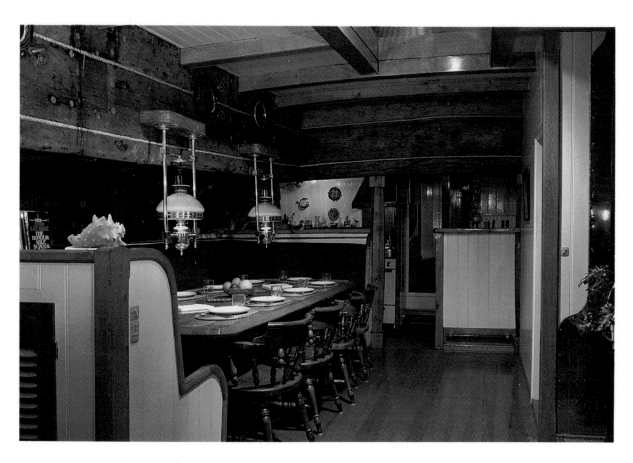

Designer/Builder—Albert Svensson; Pukavik, Sweden (launched as two-masted schooner **LINDÖ** in 1928); rebuilt with third mast in 1970 and 1977 at Ring Anderson's yard, Svendborg, Denmark

Length—125 feet (38.1 meters) overall; 92 feet (28.04 meters) on deck; 88 feet (26.82 meters) at waterline

Beam Maximum—22 feet (6.71 meters)

Draft—10 feet (3.05 meters)

Displacement—551,000 pounds (250,000 kilograms)

Total Sail Area—7000 square feet (650 square meters)

Engine Data—185 horsepower Mercedes-Benz diesel

Construction—pitchpine plank below waterline, oak plank above waterline, oak frames and keel; pitchpine deck on oak beams; fastened throughout with galvanized iron spikes, forged iron knees; pine/oak interior, pine and spruce spars, polyester sails

Home Port—Saint Thomas, Virgin Islands

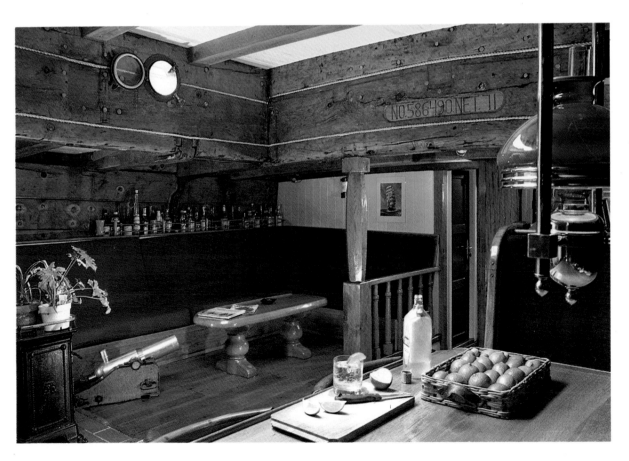

Nuovo Aiuto Di Dio

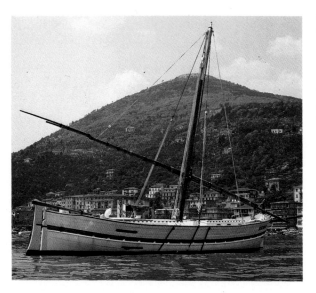

In many of the world's great seaports, there are neighborhoods with the musical sounds of Italy. The old men and women there tend to withdraw, however, and only on quiet mornings will they emerge to seek comfort in the sun. Sometimes they remember villages by rocky shores, where fishermen dried nets and mended sails, and sometimes these memories become more important as years pass in a foreign land. But only the oldest sailor might recall working aboard a "liuto," and for him the very sight of **NUOVO AIUTO DI DIO** would bring tears of joy.

The Ligurian Coast (from the French/Italian border to Viareggio) once held thousands of these sailboats. Whether they hauled sand-bags or cattle, these seaworthy vessels could survive unpredictable Mediterranean storms, yet their most frequent cargo had an almost religious significance, perhaps explaining why this particular boat was christened "new aide of God."

The cargo was wine. Big barrels of red wine, rolled into the surf after an arriving liuto had dropped all canvas and rammed the beach. An entire village would come to see the kegs wrestled into the water, then everyone would guide the kegs ashore. When the liuto was empty, long ropes went out, and by sunset the villagers had pulled the little ship safely to their heart.

In 1972, the only liutos remaining were tired old hulls stripped of masts and sails, but in the town of Riva Trigoso, wine merchant Marco Zolezzi had kept **NUOVO AIUTO DI DIO** in surprisingly good shape. A local housing contractor named Mosè Bordero even proposed restoring the liuto to its original appearance; Bordero had previously captained big oil-tankers everywhere from South America to Singapore, and his grandfather had been crew aboard a liuto, starting at the tender age of five years.

After he purchased **NUOVO AIUTO DI DIO**, from another boat Bordero salvaged a hundred-year-old mast and the enormous "antenna" spar used in traditional "lateen" (Latin) rig. Then he found original cotton sails in his wife's native Sestri-Levante. Lidia Biscio Bordero is from an old family of sailors, and she was proud that the sails were made long ago by the women of her hometown.

Designer/Builder—R. Möller; Faaborg/Fünen, Denmark
 (launched 1898)
Length—25 meters (82 feet) overall; 20 meters (65 feet 7
 inches) on deck; 18 meters (59 feet 1 inch) at
 waterline
Beam Maximum—5.0 meters (16 feet 5 inches)
Draft—2.4 meters (7 feet 10 inches)
Displacement—50,000 kilograms (110,200 pounds)
Total Sail Area—360 square meters (3874 square feet) with
 topsails
Engine Data—Volvo Penta 150 horsepower diesel
Construction—oak plank on frame, wood "treenail"
 fastened; forged iron knees and spikes; pine
 interior, pine spars, flax sails
Home Port—Hamburg, Germany

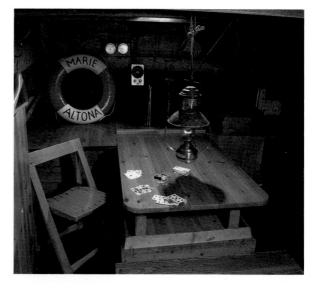

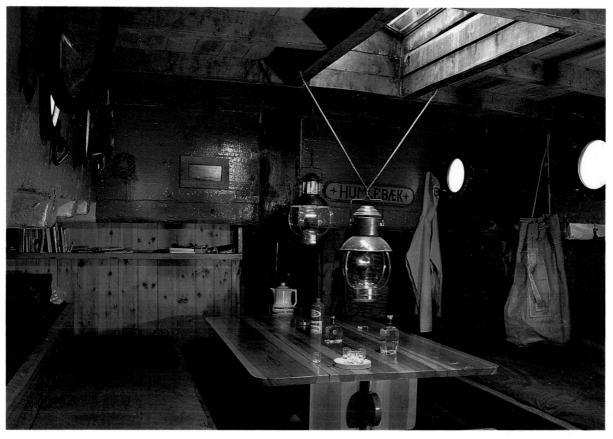

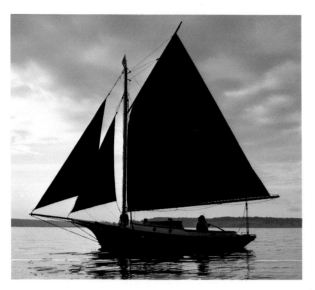

Selkie

The sailors of Maine are justifiably proud of their maritime heritage, but if some bewhiskered old shellback ever hobbles up in a Maine tavern, frowning in dismay at your out-of-state accent, there's just one sort of sailboat he'll discuss. After rattling on about local lobsters, he'll tell the story of the Friendship Sloop, followed by the customary warning that only a true, boiled-in-the-pot, "Downeast" boatbuilder can do justice to Friendship, Maine.

Well, it just ain't so. These seaworthy little sloops have been built successfully in locations ranging from Florida to Singapore, often by amateurs with only basic wood-working tools, a healthy respect for tradition, and the late Howard Chapelle's book *American Small Sailing Craft*. It might also be that Friendships have some mysterious link to musical instruments; **SELKIE**'s young builder, Jim Lyons, started out making banjos and dulcimers before taking up boats, which recalls one of America's better-known builders of Friendship sloops, Ralph Stanley of Southwest Harbor, Maine, a man who relaxes by handcarving violins.

Lyons is a native of Seattle, Washington, but now lives in nearby Port Townsend (home of the annual "Wooden Boat Festival"). He had very little childhood boating experience, least of all aboard sailing vessels, and attributes much of his interest both to a marine-carpentry course taken in 1969 at Seattle Community College and to subsequent repair work on wood fishing vessels in Alaska.

SELKIE was Lyons' first boatbuilding project and embodies concepts still dear to his heart. Most important is the minimal use of subdividing interior bulkheads, which reduce a boat's open feeling. Also, **SELKIE**'s interior furnishings each perform several functions, the most striking example of this being a portable chest which serves as dining-table, silverware storage, and alcohol stove, but which can be neatly hidden out of sight. Lyons likewise warns against too many interior panels made immovable with glued joints instead of wood screws; such joints hinder access or repair and may affect a boat's resale value to a buyer planning modifications.

Because of his experience with yacht interiors, Lyons often works for commercial boatbuilders, setting his own contract schedule and enjoying frequent vacations. On one occasion, when a surprise visitor aboard **SELKIE** produced her flask of Murphy's Irish Whiskey with which to fight the evening chill, Lyons promptly interrupted some work to produce his own surprises: a set of tiny shot-glasses, a nostalgic toast to his former travels in Ireland, and the comment that a "selkie" is an Irish mermaid.

Designer—Traditional Maine fishing-sloop (**PEMA-QUID** plans by Howard Chapelle, from the National Museum of History and Technology, Smithsonian Institution)
Builder—James C. Lyons (launched 1977)
Length—36 feet (10.97 meters) overall; 25 feet (7.62 meters) on deck; 22 feet (6.71 meters) at waterline
Beam Maximum—8 feet 6 inches (2.59 meters)
Draft—4 feet 6 inches (1.37 meters)
Displacement—6500 pounds (2949 kilograms)
Total Sail Area—500 square feet (46.5 square meters)
Engine Data—8 horsepower Yanmar diesel
Construction—red cedar plank bronze-fastened on steamed white oak frames, fir keel, teak deck; interior of teak, yellow cedar, and Eastern aromatic cedar; spruce spars, polyester sails
Home Port—Port Townsend, Washington, U.S.A.

Cherokee

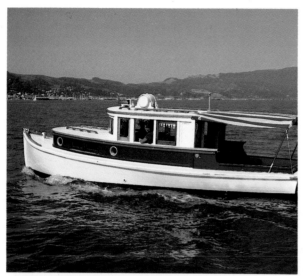

Boatbuilding may be more than some prospective boatowners want to attempt. Ann Sutter of Sausalito, California chose to buy an old one-of-a-kind fishing boat, which she and friends Nick Jewitt and Bill Hamilton converted into a cozy little cruiser.

Sutter says that **CHEROKEE** was originally called **ANY SEA**, had spent her whole life in San Francisco Bay, and was sadly deteriorated when purchased for a mere $900. Under layers of paint, however, there was a solid structure, bronze portholes, and bronze fittings. The conversion included lengthening the cabin, installing a wall-to-wall bunk in what's generously described as "the forward stateroom," and squeezing in such amenities as stereo tape-deck, gravity water system, toilet, twelve-bottle winerack, and the cockpit table-cutting board.

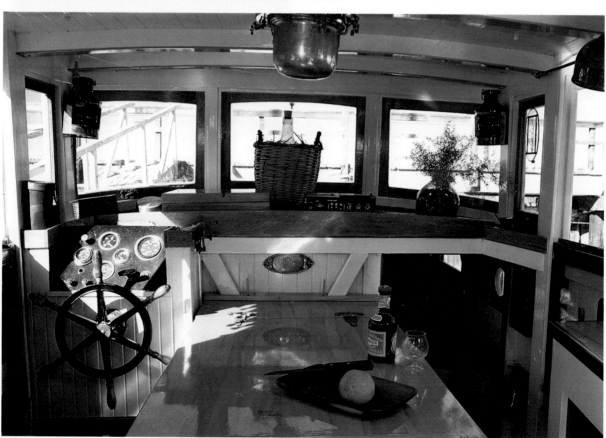

CHEROKEE spends much of her time taking weekend excursions up the Sacramento, San Joaquin, and Petaluma Rivers, all of which feed into San Francisco Bay. She has also worked as a committee-boat, carrying official observers at sailboat races, but her owner's favorite waters are off the lush green shores of Angel Island, perfect for day-long wine-tasting parties.

Sutter admits to some things aboard her boat which she might have done differently. Most important would have been the replacement of **CHEROKEE**'s gasoline engine with a safer, more reliable diesel; although all the boat's electrical wiring is new and a powerful engine-compartment blower was installed, Sutter still worries about electrical problems and the potential danger of explosive gasoline.

While shifting from work as a travel agent to her present consultation in the design of yacht interiors, Ann has also developed a theory about "boat personality." It's a theory that goes beyond a boat's appearance or seaworthiness: simply stated, some boats have minds of their own! Ann recounts how a happy group of guests once came aboard, but **CHEROKEE**'s engine wouldn't start; in case one doubts that the boat was saying something, a quick inspection discovered that a tiny fuel-tank leak had also begun, slowly dripping gasoline into the bilge. On another occasion, the boat suffered a minor engine breakdown right in front of an old mechanic who had specialized in **CHEROKEE**'s rare type of engine.

Given her changeable temperament, has **CHERO-KEE** (which her owner forcefully describes as "MY boat") ever shown any ill will toward Ann's sailmaker-husband Peter? "Not yet."

Designer/Builder—Louis Jantzen; Alameda, California (launched 1935)
Length—26 feet (7.92 meters)
Beam Maximum—8 feet (2.43 meters)
Draft—2 feet 6 inches (.76 meters)
Displacement—5500 pounds (2495 kilograms)
Engine Data—Chrysler Crown 110-horsepower, gasoline six-cylinder
Construction—Port Orford cedar plank on oak frames; canvased Port Orford cedar deck, new maple/mahogany interior
Home Port—Sausalito, California, U.S.A.

Antares

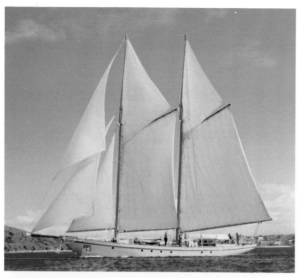

Imagine a man who not only designs and leads construction of a very fast ninety-foot schooner, but also sails it singlehanded from the Cape of Good Hope to the Caribbean, then cruises around for two years, sells out to some appreciative Americans, and flies home to South Africa with a tidy profit. Considering that Arthur Holgate sold **ANTARES** into the Virgin Island charter trade (where crew salaries are heavy expenses), his solo 1976 voyage was clever advertising at least, with superb seamanship thrown in for the fun of it.

When **ANTARES** arrived in Virgin Gorda, immigration authorities were convinced Holgate had actually smuggled his crew ashore, so Arthur demonstrated exactly how he managed the steel schooner by himself. One aged Antiguan recalled how the old native Caribbean schooners once carried cargo, produce and passen-

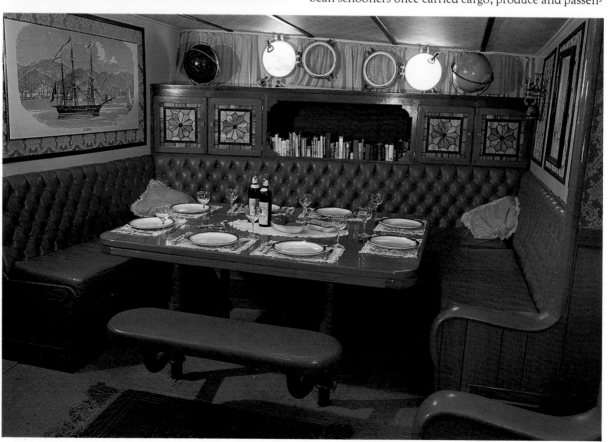

gers, and how their crews drank rainwater from sails and caught fish along their way, yet he had kind words as well for the modern **ANTARES**: "When that schooner be motoring, she handle easy like a rowboat. But when she sail, good gracious, she's gone!"

Holgate based his design on the famous Canadian fishing-schooner **BLUENOSE**, to which he added an interior layout which might inspire other luxury charter vessels. The Cruises Antares, Ltd., brochure proclaims:

Charter guests like to have equal staterooms—there are four, each with twin beds, private hot and cold shower, washbasin and head. Toilets flush like they do in your own home. The captain's cabin sleeps two with private sink, shower, and head. A separate crew quarters for three, again with sink, shower, and head...all electric galley, air-conditioning if needed...air compressor for charging scuba tanks...yes, the record turntable is gimbaled. She carries eight tons of fuel, eight tons of water, and a

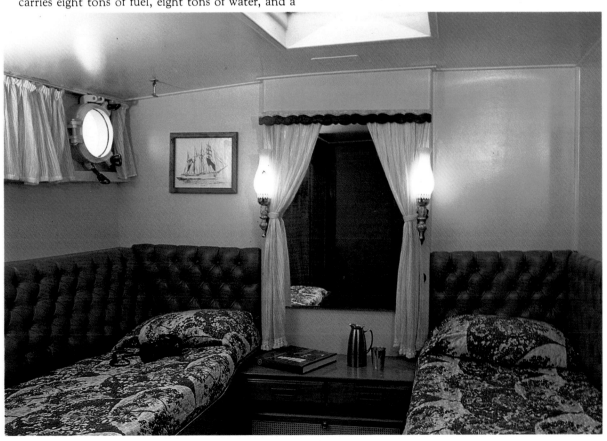

deep-freeze so large she could stay at sea for three months and be self-sufficient for eight guests plus crew. She is probably the largest vessel in the world with a self-steering windvane.

Holgate made extensive use of non-rusting alloys in topside areas where steel vessels normally lose paint. Present owners David and Roslyn Ferneding have added another trick: a protective system which charges the hull electrically against underwater corrosion. In fact, Ferneding avoids docking near other steel hulls, simply to keep **ANTARES** from electroplating her bottom with metal stolen from her neighbors! As a boatbuilder, I was impressed by Holgate's sense of economy—the naval architect's eternal war against wasted space and weight. Aboard **ANTARES**, that includes: a foremast serving as galley smokestack, a mainmast venting the bathrooms, port and starboard rub-rails each storing fifty gallons of lubricating oil, and deck cleats with threaded caps for fuel access.

Rumor has it that Arthur Holgate is planning a new schooner—three masts, 150-feet long, and carrying squaresails. Perfect for singlehanding?

Designer/Builder—Arthur C. Holgate; Capetown, South Africa (launched 1975)
Length—107 feet (32.61 meters) overall; 90 feet (27.43 meters) on deck; 73 feet (22.25 meters) at waterline
Beam Maximum—20 feet (6.09 meters)
Draft—9 feet (2.74 meters)
Displacement—176,320 pounds (80,000 kilograms)
Total Sail Area—6000 square feet (557 square meters)
Engine Data—GMC 360 horsepower diesel, with variable-pitch propeller
Construction—welded mild steel, with stainless steel trim; teak over plywood/epoxy deck on steel beams; teak/mahogany interior by Victor Montenegro; steel lower masts, other spars spruce, polyester sails
Home Port—Saint Thomas, Virgin Islands

Congar

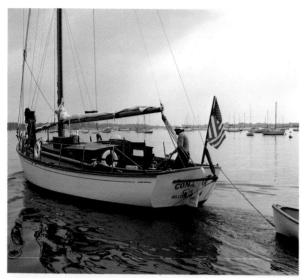

When S.J. Silberman left the United States Coast Guard and returned to New York at the end of World War II, he held the rank of Lieutenant Commander and had some strong ideas concerning seaworthy boats. The cutter-rigged motorsailer which resulted was featured in the February 1950 "Design Section" of *Yachting* Magazine, and that same vessel is now the home of Antoinette and John Stockenberg.

CONGAR's owners, like many live-aboard sailors, have well-considered opinions about their experience, so I'd rather let Antoinette speak for herself:

"The prospect of moving aboard a boat seems formidable to many—it isn't. It took us less than three months to sell everything and move our clothes, personal effects, and cat onto our new home. Before then, we had researched wood boats (about which we knew nothing),

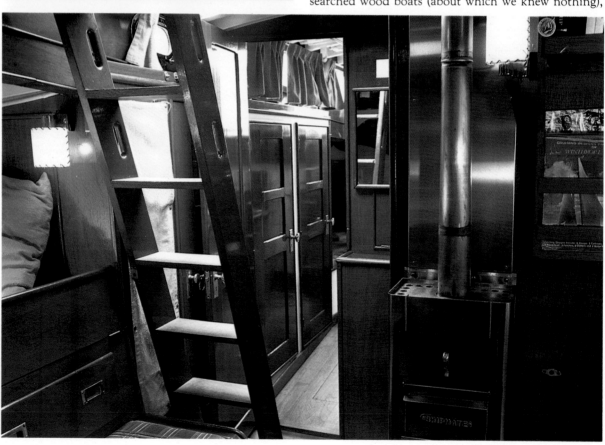

deciding to buy one that would be liveable and comfortable immediately (no major repairs or installations), possessed seagoing abilities for eventual long-range cruising, had an attractive pedigree (because we bought her partly for investment purposes), and made our hearts thump at first sight.

"In the four years we have lived aboard **CONGAR** in the northeast United States, we have found the boat virtually a perfect liveaboard. Creature comforts include: refrigerator, freezer, and pressure hot water from a gas heater; a galley capable of turning out a turkey dinner and all the trimmings for six; excellent provisions for privacy, including two heads with showers, when cruising with guests; unusually large closet and hanging-locker space.

"With the help of self-tailing and self-storing winches, roller-furling headsail, and self-tending staysail, the boat is easily handled by two, performs surprisingly well, and on windless days, the diesel gets us where we want to go

at nine knots. On the other hand, the boat is certainly a maximum-maintenance involvement; we do almost all the work ourselves, and it requires a certain amount of discipline and resignation to keep the maintenance in perspective.

"Generally, we have found living aboard to be completely compatible with an office-job routine, only instead of walking down the driveway to our car in the morning, we row the dinghy ashore."

Sailors often have unusual pets, but **CONGAR**'s resident fifteen-year-old feline is a real prize. The cat's name is "Moose," he's pure white, and he's got eyes of different colors—yellow and blue. And there's more: shine a flashlight in Moose's eyes late at night and the starboard one's gone green while there's a red eye to port. Navigation lights!

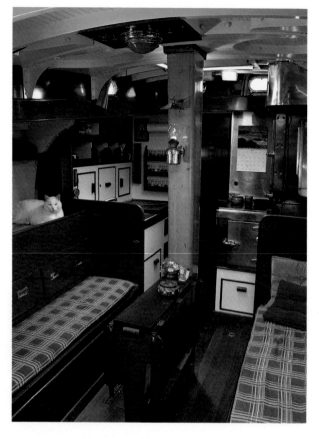

Designer—Winthrop L. Warner

Builder—Paul E. Luke; East Boothbay, Maine (launched 1949)

Length—49 feet (14.9 meters) overall; 42 feet 8 inches (13.0 meters) on deck; 38 feet 4 inches (11.7 meters) at waterline

Beam Maximum—12 feet (3.66 meters)

Draft—5 feet 8 inches (1.73 meters)

Displacement—40,800 pounds (18,511 kilograms)

Total Sail Area—929 square feet (86.3 square meters) working rig; 1033 square feet with genoa

Engine Data—Perkins 130 horsepower diesel

Construction—Honduras mahogany plank on white oak frames, bronze-fastened, forged bronze floors; teak decks, mahogany interior; spruce spars, polyester sails

Home Port—Newport, Rhode Island, U.S.A.

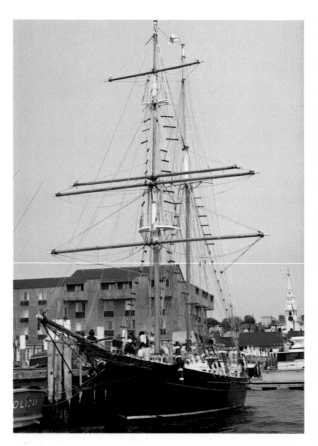

Black Pearl

The average resident of Newport, Rhode Island, could easily direct the newcomer to the Black Pearl, that local tavern patronized by America's Cup skippers and their stalwart crews. A more informative resident might mention the tavern's namesake, a vessel which figured in maritime history, but only the most knowledgeable native could tell you about Barclay H. Warburton III, who once owned the famous tavern and now captains a very different, waterborne **BLACK PEARL**.

For someone who graduated from Harvard College, served in the U.S. Navy, ran a dairy farm, and served in the Massachusetts State Legislature, Barclay Warburton prefers a low public profile, but this doesn't harm his public influence. As President of the American Sail Training Association, Barclay Warburton has quietly affected millions of people's lives, beginning with those young men and women who learn aboard A.S.T.A. vessels, and ending with every wide-eyed tourist who has seen the world's Tall Ships come into port.

In 1972, the United States sent one big squarerigger (the Coast Guard's **EAGLE**) to Kiel, Germany, for the Tall Ship Races honoring the Twentieth Olympics at Munich; since these international Races had begun in 1956, American sailors had never been thus represented. However, the 1972 event was to include the smaller "Class B" vessels: nine from West Germany, six from Poland, six from Sweden, eight from Great Britain, and so forth, but none from America. With this in mind, Barclay Warburton rebuilt **BLACK PEARL** as a sail training yacht (half her crew must be between sixteen and twenty-five years of age), and he sailed the little "hermaphrodite brig" to Germany. It was a small gesture, but when the sailors at Kiel later received invitations to America's Bicentennial celebration, it was a gesture they remembered.

But all is not weighty business aboard **BLACK PEARL**; the boat's seagoing green parrot, "Shipwreck," sees to that—by talking, singing, and even whistling. At one time, one could have found the sea-dog "Willy," a terrier with an Atlantic crossing to his credit. Willy had a private cabin on the foredeck and displayed two special traits: he preferred the company of women to that of men, and he could bite.

Designer—Edson I. Schock
Builder—Lincoln Vaughan Shipyard; Wickford, Rhode
 Island (launched 1948)
Length—62 feet (18.9 meters) overall; 51 feet (15.5 meters)
 on deck; 42 feet (12.8 meters) at waterline
Beam Maximum—15 feet 6 inches (4.72 meters)
Draft—8 feet 3 inches (2.51 meters)
Displacement—103,588 pounds (47,000 kilograms)
Total Sail Area—2000 square feet (186 square meters)
Engine Data—Chrysler/Nissan 165 horsepower diesel
Construction—yellow pine plank on oak frames, bronze-
 fastened; teak decks, mahogany interior;
 spruce spars, polyester sails
Home Port—Newport, Rhode Island, U.S.A.

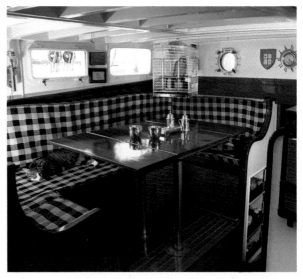

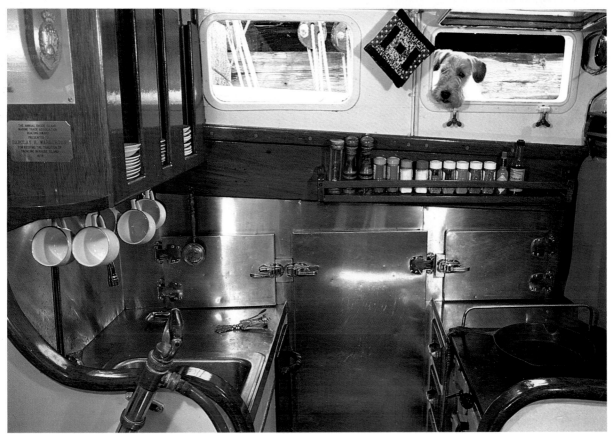

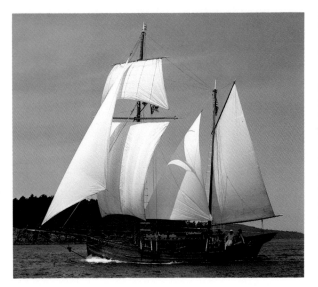

Sunrise

Yacht design, as any yacht designer will tell you, is no way to get rich. If one deals primarily in traditional sailboats, then much of the yachting public takes its business elsewhere, and if a designer starts tinkering with tradition, then even the old-fashioned purists abandon ship.

Surprisingly, Jay Benford hasn't suffered from this predicament. Headquartered in Friday Harbor, Washington, Benford has allowed many sailors to brand him a traditional designer, and he has likewise heard some criticism for having suggested such conveniences as roller-furling square rig, but a substantial business nevertheless continues at Jay R. Benford & Associates. This is largely due to Benford's reputation for drawing solid, seaworthy cruisers and for his frequent supervision during construction of clients' boats. Credit also goes to Benford's wife, Robin, who manages the public relations and has proven herself an outspoken, central force in the Benford design office.

Much of the Benfords' credibility comes from their "pinky" ketch **SUNRISE**. Designed for clients who were later unable to finance completion, **SUNRISE** was purchased by the Benfords, thereby becoming a home and demonstration of Jay's talents. The boat is also a floating testimonial to the trademarked Deks Olje, a Norwegian wood finish that looks like conventional varnish but requires a fraction of the usual maintenance, allowing the Benfords to enjoy both dockside admiration for **SUNRISE** and sailing!

Having grown up on the shores of Lake Ontario, where he sailed his own twenty-two-foot gaff sloop, Jay Benford became interested in naval architecture and eventually worked for the esteemed designer John Atkin of Connecticut; later employers included the Foss Tugboat Company and commercial boatbuilders in the American Northwest. Robin Benford, a native of British Columbia, first used her Canadian teaching certificate in the Ladysmith school system, and later she was employed in the news department of a Vancouver television station where she met her husband.

The term "pinky," by the way, refers to the unusually long and pointed extension of **SUNRISE**'s aft deck over the rudder. It's yet another boating term with a complex international history, but it's worth noting that traditional fishing-vessels equipped with a "pink" stern used them for drying nets, for supporting the boom and sails when at anchor, and, because privacy at sea wasn't a problem, as a wonderfully windy toilet.

Designer—Jay R. Benford
Builder—Bill Modrell; Tripple & Everett Marine Ways, Seattle, Washington (launched 1973); outfitting by Mantra Marine and Vic Franck's Boat Company

Length—50 feet (15.24 meters) overall; 38 feet (11.58 meters) on deck; 34 feet (10.36 meters) rudderpost to stem; 30 feet 8 inches (9.35 meters) at waterline
Beam Maximum—11 feet 3 inches (3.43 meters)
Draft—6 feet 3 inches (1.9 meters) fully loaded
Displacement—31,240 pounds (14,174 kilograms) fully loaded
Sail Area—Fore/Aft Sails, 770 square feet (71.6 square meters); Mizzen Staysail, 180 square feet (16.7 square meters); Squaresails, 468 square feet (43.5 square meters)
Engine Data—25 horsepower Volvo diesel
Construction—red cedar over oak frames, bronzefastened; decks and interior of fir, cedar, teak; spruce spars, polyester sails
Home Port—Friday Harbor, Washington, U.S.A.

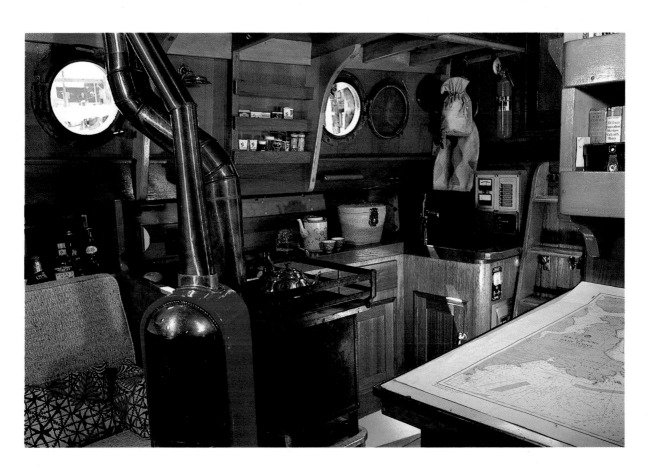

Wild Goose

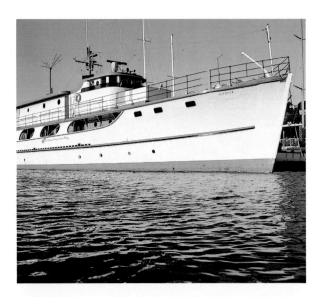

One sunny day in 1965, a huge motoryacht came rumbling into the harbor of Newport Beach, California. Named **WILD GOOSE**, she was making her first appearance after a long reconstruction and was carrying, along with the crew and owner's family, a good number of guests. As the old boat rounded into sight of the many fancy cruisers which frequent that harbor, a loud cheer and blowing of horns was heard from the waterfront, and a little waterborne parade was quickly formed to welcome the **WILD GOOSE** home. Up on the bridge of the **GOOSE**, a six-year-old girl turned to her father and, imagining no other reason for the noise, exclaimed, "You must have the prettiest boat in the harbor!" The father turned to his daughter and, in what could have been a great imitation of John Wayne playing

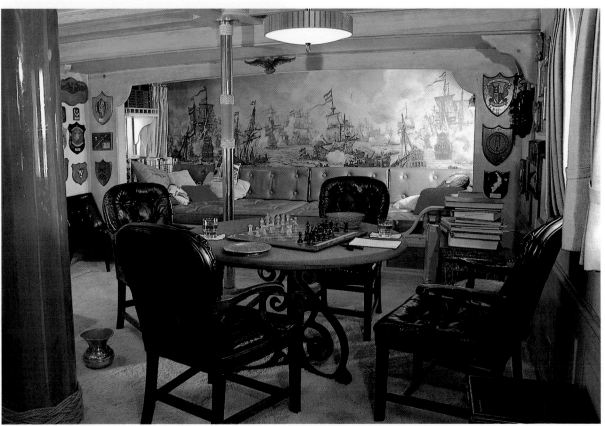

cowboy, answered, "No, not by a long shot. But I might just have the most comfortable."

Only it wasn't an imitation. The real John Wayne bought the **WILD GOOSE** in Seattle, Washington, from timber-and-tugboats entrepreneur Max Wyman. She was nothing more than a converted U.S. Navy minesweeper, built of wood so she couldn't set off magnetically triggered explosives, and built simply so she wouldn't cost too much. Wayne had the low cabin roof raised here and there, and a constant flow of new furniture ran through the boat, but she's basically an unpretentious affair, built for comfort, not for speed.

Why would a man who could afford just about anything afloat choose an old minesweeper? One reason is that The Duke, however much the actor on screen and off, needed a retreat like anyone else, and it didn't have to impress anybody with genuine this or varnished that.

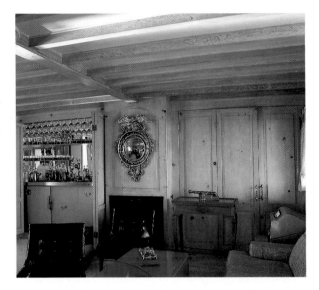

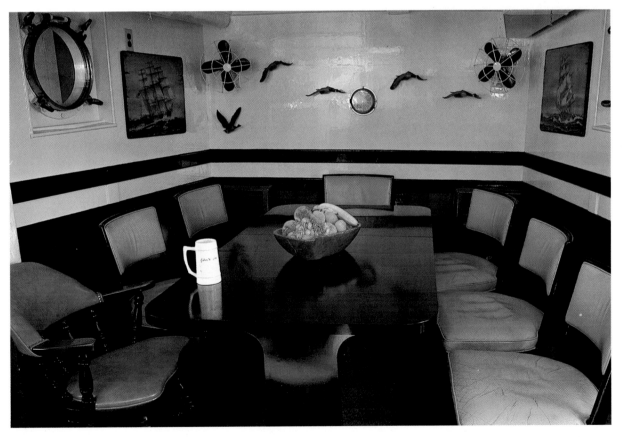

And although he had done a good bit of sailing when much younger, he wanted a reliable powerboat, a big one, something with "plenty of accommodations for the family." Having resisted everyone's advice that he should junk the **GOOSE** and instead buy a "real yacht," Wayne went further and stocked his 136-footer with a heating and air-conditioning system, auxiliary generators, and even a good movie projector.

Whatever her beauty in the eyes of the beholder, **WILD GOOSE** was a favorite from Acapulco to Puget Sound, from Spain to Bermuda. When she tied up, parties started happening spontaneously, and faces seen the previous night on television would appear in the flesh, and the crew seemed somehow to be, not just the hired help, but a totally necessary part of the action.

Behind all of this stood a complicated man who worked hard to earn his comfort. Wayne made more than two hundred films and became the world's "box-

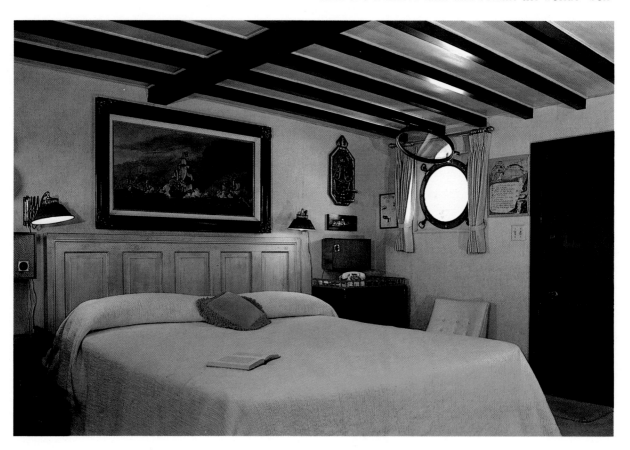

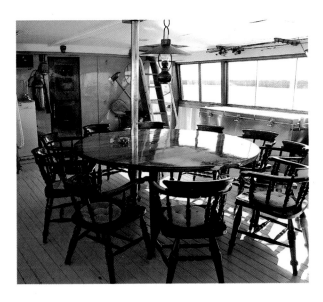

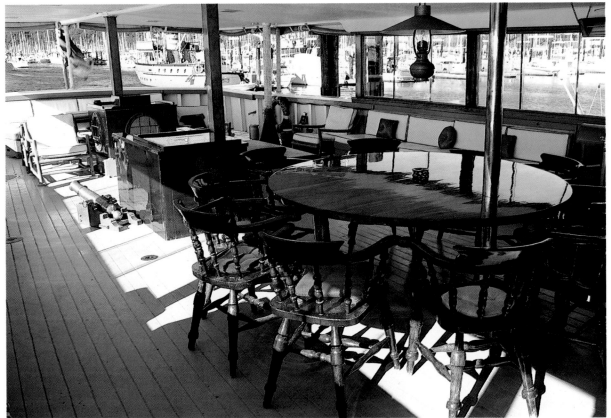

office champion." He fought it out with lung-cancer and hepatitis, he'd talk your ears off about politics or poker, he raised seven kids. There was one "failure" along the way, though, and maybe it explains why, under The Duke's ownership, the old minesweeper never completely lost her gray paint. Back in high school, the football hero whose name was Marion Michael Morrison tried for a berth with the United States Naval Academy at Annapolis, Maryland, and he found himself high on the list of probable candidates. By just one place in the standings, the Navy lost a good sailor, and Hollywood gained a star.

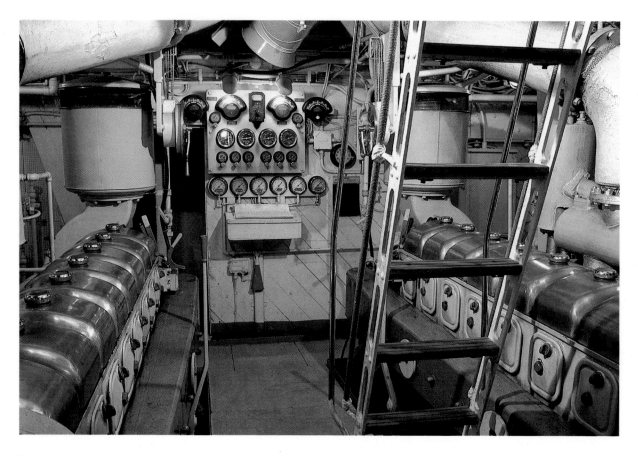

Designer/Builder—U.S. Navy contract, Ballard Marine Railway Company; Seattle, Washington (launched 1943)

Length—136 feet (41.45 meters) overall; 128 feet (39.01 meters) at waterline

Beam Maximum—25 feet (7.62 meters)

Draft—9 feet (2.74 meters)

Displacement—632,548 pounds (287,000 kilograms)

Engine Data—two Cleveland GMC diesels, 500 horsepower each

Construction—Douglas fir throughout, double-planked below waterline

Home Port—Newport Beach, California, U.S.A.

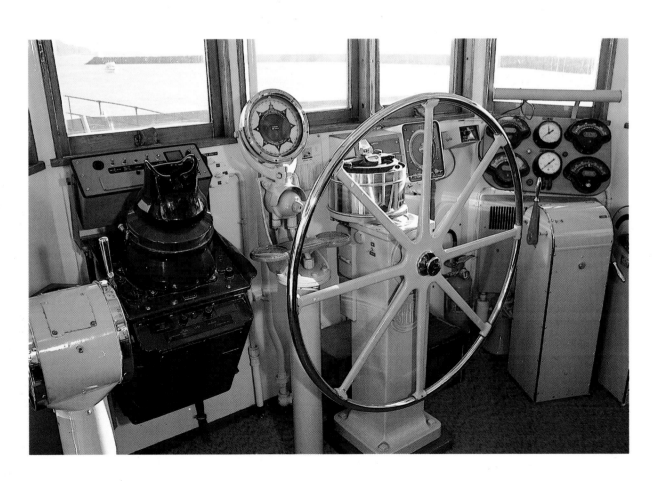

Taihoa

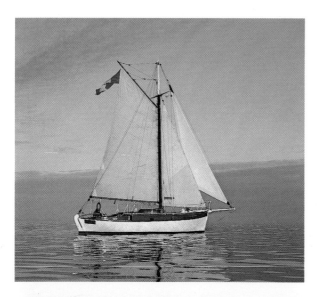

The Strait of Juan de Fuca is bordered by the state of Washington and Canada's Vancouver Island. It can be calm as a country lake or get nasty with storms that destroy entire ships, floating logs so huge they barely move in ocean swells, and the fins of the mighty Orca—the "killer whale." The Strait can produce fogbanks as thick as cement, yet local fishermen often watch the fog burn off at dawn, to leave a rainbow arching from horizon to horizon.

It is in these wild waters that **TAIHOA** sails. A double-ended, raised-deck cutter along the lines of Colin Archer's Norwegian lifeboats, **TAIHOA** is the home of Michael King-Brown, a young dentist in Victoria, British Columbia. King-Brown's theories on proper boat maintenance follow seven years afloat and two basic principles: Murphy's Law ("if something can possibly go

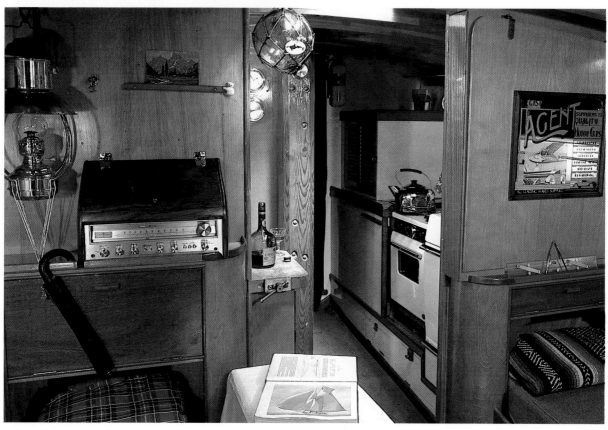

wrong, it will") and Ramsey's Law ("Murphy was a raving optimist"). So although **TAIHOA** seems like other yachts tied up along Victoria's Fishermen's Wharf, underneath that stereo system and shiny varnish there's a vessel ready for rough weather.

King-Brown doesn't even bother to defend **TAIHOA's** modern touches, which include a roller-reefing mainsail, roller-furling jib, and self-tailing winches, but cites John Leather's book *Gaff Rig* as inspiration for modifying traditional rigs. When not sailing with an able and winsome crew, King-Brown can now singlehand his self-steering cutter with only the rare departure from the cockpit.

Perhaps the most important perspective gained from living aboard **TAIHOA** concerns the popular concept of luxury. Not being a homeowner, King-Brown uses far less living space than do most individuals, while allowing himself a more refined taste with creature comforts. Aboard his boat, that means having the time and financial resources necessary for installing a fairly complex electrical system, insulated from the salt-water environment; considerable energy also went into assembling a varied tool kit, storage areas for food and clothes, and a library that could satisfy even the slowest round-the-world cruise. On land, however, King-Brown travels in equal splendor: an absolutely perfect, scarlet and ivory mid-Fifties Cadillac, with fat whitewall tires, original wire wheels, and pushbutton everything.

Designer—George Band
Builder—J.N. Simmonds; Vancouver, British Columbia (launched 1947)
Length—48 feet (14.63 meters) overall; 37 feet 10 inches (11.53 meters) on deck; 35 feet (10.67 meters) at waterline
Beam Maximum—11 feet (3.35 meters)
Draft—5 feet 10 inches (1.78 meters)
Displacement—32,000 pounds (14,518 kilograms)
Sail Area—850 square feet (79 square meters) without topsail
Engine Data—Ford 65 horsepower diesel
Construction—red cedar plank on steamed oak frames, fir keel, yellow cedar stem and rudderpost; red cedar deck over laminated fir beams, covered with fiberglass cloth in latex bedding compound; interior of red cedar, mahogany, birch plywood; solid fir spars, polyester sails
Home Port—Victoria, British Columbia, Canada

Alicante

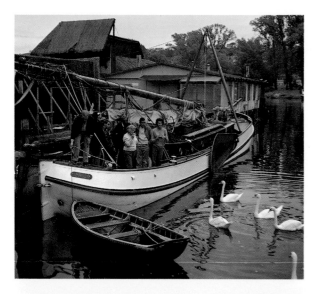

As the wee hours come to waterfront taverns, and the conversation of tipsy sailors turns to favorite ports-of-call, sometimes you hear of Pelican Harbour. It's a warm little slice of Sausalito, California, filled with strange accents and a motley crew, but its fame comes from the variety of classic old boats sheltered there against the winds of San Francisco Bay.

Ned Martin owns and manages Pelican Harbour, not just by assigning berths and collecting rent, but by taking part in the Harbour's daily life. After helping a recent arrival, for example, with groceries and repairs, Ned retires to survey his domain from aboard a very special yacht. His hundred-year-old iron **ALICANTE** might at first seem out of place in a marina devoted almost exclusively to wooden boats, but she bears an astounding

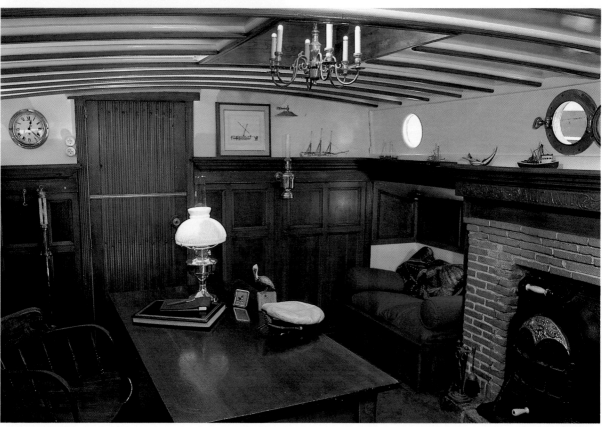

history and has traveled as much as any of her wooden neighbors.

Originally a working "tjalk" that once carried peat, grain and produce in the Netherlands canals and Zuider Zee, **ALICANTE** was converted into a pleasure craft long ago by the De Groot family, famous as manufacturers of ladies' dresses. During three generations of De Groot ownership, the tjalk spent much of her time at the Royal Netherlands Yacht Club and counted the Queen of Holland among her many guests. The boat's original name, **VROUWE SOPHIA**, was changed to honor the Spanish city where a newlywed De Groot couple spent their honeymoon.

ALICANTE was purchased in 1967 by William Purdy of Burlingame, California, and after some cruising in Holland, was shipped as deck cargo to the Virgin Islands for a brief career as a charter vessel. By the time Ned Martin acquired her, the tjalk had moved an impressive

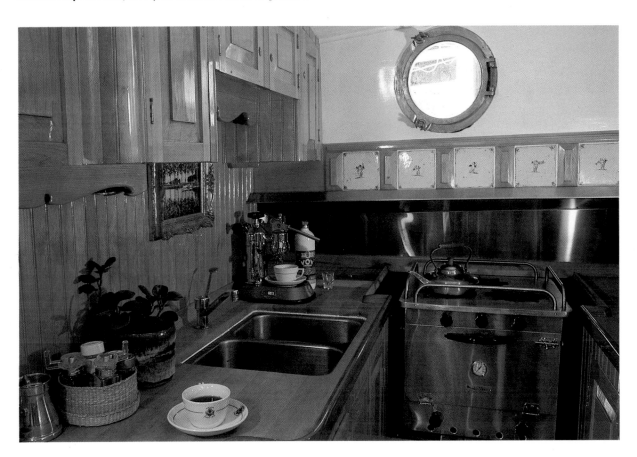

amount of water under her keel: the canals of France and Holland, the North and Baltic Seas, up the Rhine River to Heidelberg, down the English channel to Dover and Calais, the Italian and French Riviera, as well as other parts of the Mediterranean, and the Caribbean.

Although current work aboard **ALICANTE** has included a new galley, electrical system, and tile bathtub, most of the traditional interior remains, as does the boat's original "tabernacle" rig, with a mast hinged to pass under canal bridges. But Martin isn't restoring his shoebox-shaped classic just for the hell of it. Whatever her history until now, **ALICANTE** is scheduled to take her new owner on his "Ultimate Cruise to Europe."

Designer/Builder—traditional Friesland tjalk, designer/ builder unknown (launched 1882?); interior redesigned in 1946 by Firma G. de Vries Lentsch, Nieuwendam, Netherlands
Length—82 feet (24.99 meters) overall; 70 feet (21.34 meters) on deck; 68 feet (20.73 meters) at waterline
Beam Maximum—14 feet (4.27 meters)
Draft—2 feet 6 inches (.76 meters); 6 feet (1.83 meters) leeboards down
Displacement—90,000 pounds (40,833 kilograms)
Total Sail Area—1800 square feet (167 square meters)
Engine Data—125 horsepower Volvo diesel
Construction—riveted iron plate throughout; teak decks with mahogany trim; oak rudder and leeboards; interior of teak, oak, hemlock, cedar; pine mast, polyester sails
Home Port—Sausalito, California, U.S.A.

Sonja Elar

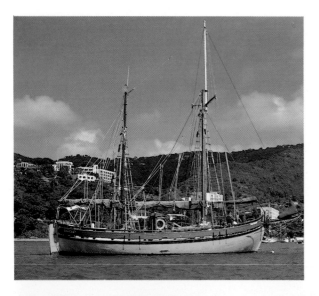

When Phyllis Fredette bought this heavy double-ender in Florida, she and George Gaskill knew only that **SONJA** had once been an engine-driven Norwegian fishing-boat with just a small steadying sail for use in rough weather. Fredette had been reading a book written by Idries Shah and entitled *The Sufis*, which described a mythical people who defied their rulers and developed a waterborne community of fishermen and boatbuilders; those people had been called El Ar, a name soon added to the original **SONJA**.

Fredette described her previous life in southern California as "total suburbia," which she and her three children left when the roomy ketch **SONJA** became their new home. Before joining them, George Gaskill had lived in California and Hawaii; instead of the usual route through the U.S. Merchant Marine Academy, he had

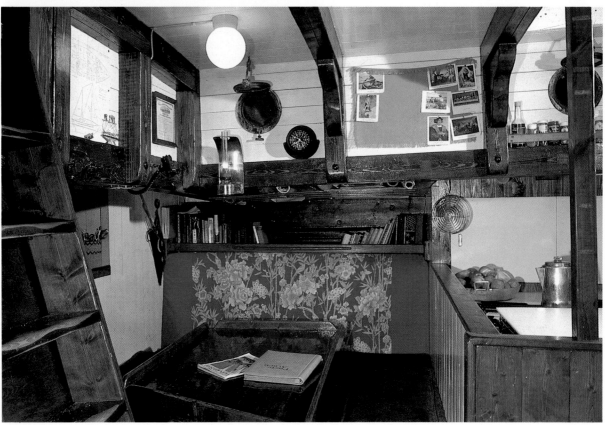

worked at sea to earn a Master's License for the operation of steam and diesel vessels weighing up to three hundred tons, and his experience included years aboard tugboats, fishing-trawlers, oil-platform supply boats from Texas to Trinidad to Singapore, even aboard seismographic survey craft with Shell Oil Company.

Not much was known about **SONJA**'s early years before a friend named Fred Sladen purchased and converted her in Norway, so research on their behalf soon proved how helpful people can be in the Norwegian local government. A letter sent to the communities of Stord and Risør discovered both the builder's name and that a Mr. Peter Alvestad of Føresvik, Bokn, had originally used **SONJA** in the sprats and herring fishery; the second owner had been Hans Haaland of Kvitsøy, who used the boat for shrimp-trawling until his death in 1971. Trygve Kolshus is Technical Chief Engineer in Stord and says that many Norwegian workboats have become round-the-world cruisers; despite her unadorned interior and humble appearance, **SONJA ELAR** fulfills her owners' dreams as well as any luxury sailboat could, and probably better.

Designer/Builder—Rød Shipyard; Risør, Norway (launched 1930)

Length—60 feet (18.3 meters) overall; 49 feet (14.9 meters) on deck; 46 feet (14.02 meters) at waterline

Beam Maximum—17 feet 10 inches (5.44 meters)

Draft—7 feet (2.13 meters)

Displacement—121,220 pounds (55,000 kilograms)

Total Sail Area—1200 square feet (111.5 square meters)

Engine Data—120 horsepower Detroit Diesel, with belt-drive variable-pitch propeller

Construction—larch plank and oak garboard on oak frames/keel, iron bolts and "treenail" fastened; larch deck on larch beams, pine ceiling and interior; fir spars, polyester sails

Home Port—"wherever the anchor lands"

Pretantaine

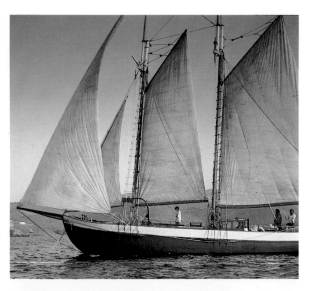

Vacationing aboard a crewed yacht can lack a personal touch, at least if the paid crew is looking forward to getting home after work, so the Yacht Charter Center of Piraeus offers a sailboat with all the comforts of home. Although Sebastian Schäffer and Toni Niessen are a long way from their native Austria and Germany, they enjoy year-round residence aboard **PRETANTAINE** just as much as their charter guests enjoy sailing the Mediterranean, and the relaxed shipboard atmosphere makes all the difference in the world.

Unfortunately, neither of her owners has discovered much about **PRETANTAINE**'s early history. Schaffer wrote to naval architect Fernand Hervé of La Rochelle, France, soon after buying **PRETANTAINE** in 1974, hoping to confirm that Hervé had designed or built the

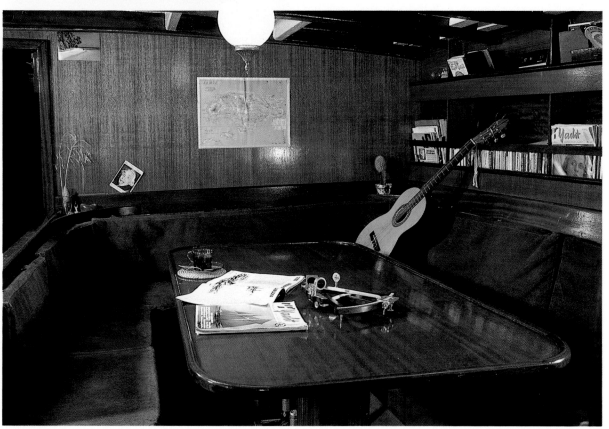

old schooner; the surprise answer was that Hervé's boatyard had been founded in 1946, making his supposed 1928 construction of **PRETANTAINE** quite impossible. The only explanation was that, after his predecessor's boatyard and company files were destroyed in World War II, Hervé had been credited with the boat's design simply because he now occupies her birthplace. While disclaiming such credit, Hervé wished Schäffer and Niessen the best of luck, noting that traditional French sailboats don't always find such skilled and appreciative owners; despite her charter work, the schooner has retained a simple interior built from boldly patterned, extremely hard African mahogany.

As for atmosphere, it would be difficult to enjoy life more than it is savored aboard **PRETANTAINE** (her name, appropriately, means "life of pleasure" or "escapade"). Schäffer and Niessen work quietly to maintain the old schooner, yet their neighbors always know when someone's around: be it Bob Marley reggae, flamenco by Manitas de Plata, or a Mozart sonata, the music flowing from **PRETANTAINE** could only come from powerful home stereo-equipment. Schäffer claims the vibration helps to remove old varnish.

Designer/Builder—unknown, thought to be "Chasseigne" of La Rochelle, France (launched 1928)
Length—22 meters (72 feet 2 inches) overall; 19 meters (62 feet 4 inches) on deck; 15.47 meters (50 feet 9 inches) at waterline
Beam Maximum—4.50 meters (14 feet 9 inches)
Draft—2.6 meters (8 feet 6 inches)
Displacement—55,000 kilograms (121,220 pounds), Thames Measurement Tonnage
Total Sail Area—165 square meters (1775 square feet)
Engine Data—GMC 100 horsepower diesel
Construction—oak plank, frames, and keel, fastened with galvanized iron nails; iroko deck, mahogany interior; pine and spruce spars, polyester sails
Home Port—Pasalimani, Piraeus, Greece

Ming Hai

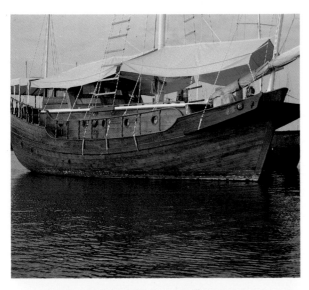

When nine-year-old Bahama Maggio comes home after school, the first thing she does is take off her shoes. Sure, she does it at a full gallop, and the shoes land just about anywhere, but the youngest member of the Maggio family has a home worth keeping clean. Very few people get to live aboard a genuine, made-in-Hong-Kong Chinese junk.

Few children have parents as unusual as Bahama's, either. Her mother, Barbara, was a registered nurse before opening a women's clothing boutique in Florida. Now she also manages the family business, "Inter-Island Schooner and Trading Company," which sails the 56-foot **WILLIAM H. ALBURY** out of the Abaco Islands in the Caribbean. Bahama's father, Joe, is captain aboard the **WILLIAM H. ALBURY** and once worked for the U.S. Central Intelligence Agency, later writing

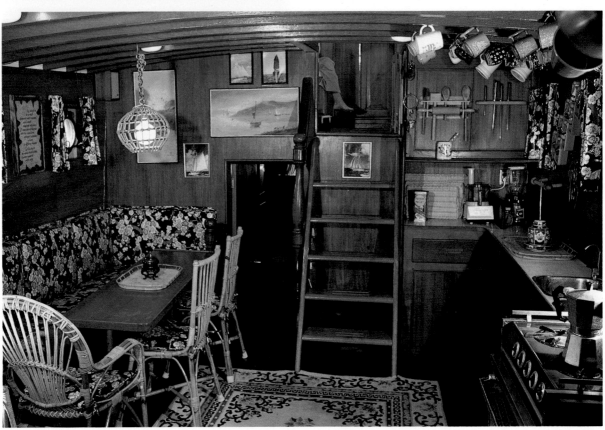

the book *Company Man* about his experience in war-torn Vietnam. When military service ended, Joe Maggio decided to try a more peaceful life, and he knew enough about traditional Chinese sailboats to envision one of them as a permanent home.

Most sailors comprehend neither the variety of junk types which China has developed through the centuries nor that country's extensive seafaring tradition. Books such as G.R.G. Worcester's *Junks and Sampans of The Yangtze* challenge the idea of European supremacy at sea. Westerners believing, for example, that the mariner's compass was invented by Flavius back around 1300 A.D. do so in ignorance of a man called "Huang Ti," who demonstrated what he called a "south-pointing chariot" made from lodestone in the year 2697 B.C. Huge sea-going Chinese junks were boldly sailing to India and Africa long before European ships began leaving coastal waters; even sailors of modern high-performance cata-

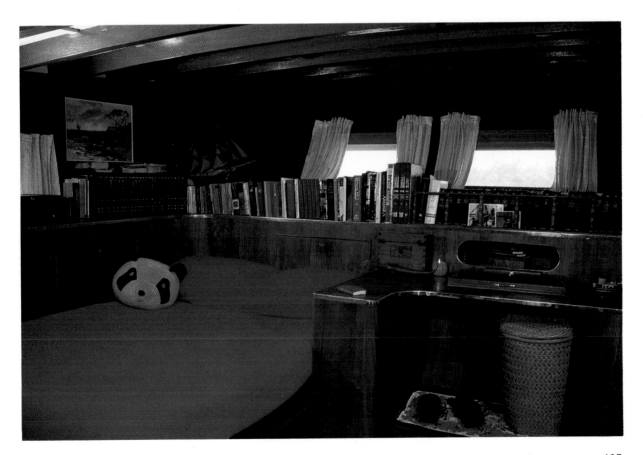

marans will tell you that the ancient, bamboo-battened "lug rig" of China is one of the most easily handled, aerodynamically efficient sail systems ever created.

So when **MING HAI** (meaning "clear and bright seas") was put up for sale after being commissioned by a wealthy American farmer who died during the yacht's construction, Joe Maggio's search for a genuine Chinese junk ended. Built to very high standards, the junk had only the finest lumber used in her design, with extra touches including the admittedly untraditional wheelhouse and oversize main cabin. Maggio then finished off the interior himself, kept the rig small for safety, shipped **MING HAI** home across the Pacific Ocean, and celebrated his luck with a 2000-mile Caribbean cruise. As the junk became an established home, her dark interior collected lots of bamboo furniture and fabrics glowing with colors—especially a vibrant Chinese red.

Designer/Builder—Master Carpenter H.K. Ho; Tai Lee Cheung Slipway, Hong Kong (launched 1972)
Length—49 feet 10 inches (15.19 meters) overall; 48 feet 2 inches (14.65 meters) at waterline
Beam Maximum—22 feet (6.71 meters)
Draft—6 feet 6 inches (1.98 meters)
Displacement—145,464 pounds (66,000 kilograms)
Total Sail Area—900 square feet (83.61 square meters)
Engine Data—Mercedes Benz 150 horsepower diesel
Construction—oiled Cambodian teak throughout, yacal keel, Monel-fastened; cabin-roof of mahogany plywood over yacal beams, teak interior; spruce masts, polyester sails
Home Port—Coconut Grove, Florida, U.S.A.

Cyclade

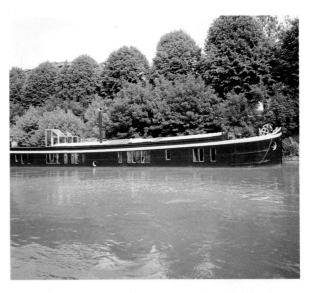

Patrick Okorokoff is a licensed French architect who lives aboard the peniche **CYCLADE**. To him, life on the Seine is simply a relaxed and more pleasant work situation than Paris normally offers, and his specialty is the use of solar energy in family dwellings. **CYCLADE** is a sensible place to entertain clients and friends.

Although the word actually has many spellings and describes a variety of traditional European shallow-water craft, most French sailors give the name "peniche" to any barge-like affair found on rivers or canals. A peniche is often some old wood vessel from the Netherlands, or an ancient tugboat converted to live-aboard use, but **CYCLADE** is the real thing: built to carry bulk cargoes slowly on the European inland-waterway system, the heavy barge would be quite out of place at sea.

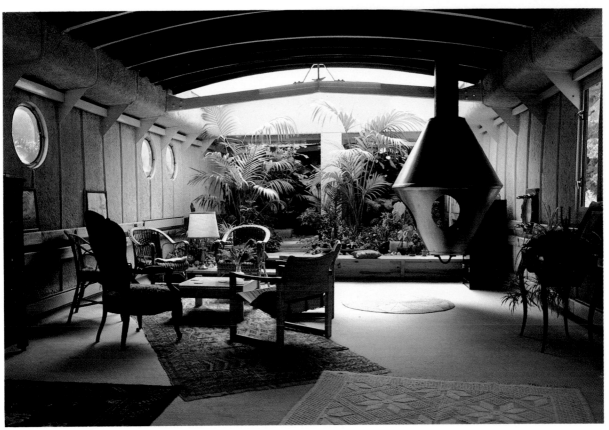

When Okorokoff bought **CYCLADE** in 1974, he left
the original interior in the wheelhouse and the tiny aft-
cabins, but the entire cargo-hold suddenly became living
space. Enough ballast was put in to create stability, then
a solid floor was built, and most of the exposed steel in-
terior was sprayed with adhesive fiberglass insulation.
Then came carpets, a fireplace, and a wonderful garden
under the wide cargo-hatch, followed by an extensive
electrical system and well-equipped kitchen. Even
though Okorokoff's work requires that he hears the tele-
phone when it rings, his superb stereo system has a
potential for volume that must be heard to be believed.

The major disadvantage which most people see in life
aboard a boat—that of inadequate living space—is ob-
viously less of a problem in something as roomy as

CYCLADE, but Okorokoff wasn't wasteful. Sleeping-quarters and storage were made only as large as necessary, while the central dining and lounge areas are left open, with only the occasional hanging fabric or group of plants dividing the space. Even the spiral staircase ascends without interrupting the view, and a new row of windows lets one wave to rowboats or feed the passing ducks.

Many Parisian boat-people take summer vacations by starting up the engine, casting off all lines, and wandering along the interconnected European canals. This way of life is an Old World tradition, for it brings different cultures together in harmony, and it is a way of life destined to survive.

Designer/Builder—Van Damme; Te Baasrode, Belgium
(launched 1927)
Length—38.44 meters (126 feet 1 inch)
Beam Maximum—5.07 meters (16 feet 8 inches)
Draft—.76 meters (2 feet 6 inches) presently; 0.43 meters
empty; 2.37 meters with full cargo
Displacement—142,000 kilograms (312,968 pounds) pres-
ently; 81,000 kg. empty; 361,000 kg. with full
cargo
Engine Data—GMC 165 horsepower diesel
Construction—riveted mild steel throughout, pine decks;
new pine/oak interior
Home Port—Paris, France

Hawaita

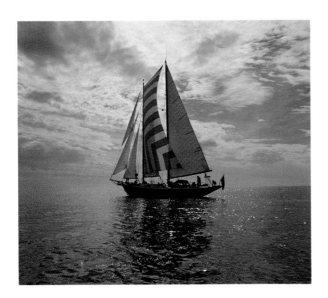

Sailors who have thought of Spain as isolated, perhaps by politics or geography, should hear David and Jennifer Power warmly describe Spanish hospitality, for this English couple was enjoying life on the Costa del Sol long before it became some of the world's most fashionable waterfront.

David Power was the hired captain of **HAWAITA** from 1965 to 1968 and eventually bought the schooner, later beginning charter work to cover his expenses. The yacht had sailed primarily along the southern coast of France, to which the Powers soon added over 40,000 miles of cruising in the Mediterranean and to the Canary Islands.

The yacht had carried the name **FRANIK II** during previous service with a Swiss owner, but her original ownership explains why she displays such superb construction. In 1932, King George V of England presented this schooner as a gift to Sir Philip Hunloke, sailing-master aboard the Royal Yacht **BRITANNIA**, who called his lucky acquisition **VERA MARE**—Latin for "Truth of the Sea." The royal influence on the yacht's seaworthy design can be seen both in the overall fact that her sailing abilities were not compromised and in minor details such as the original stainless-steel rigging, a rare feature at the time of her launch.

Because this heavy yacht was designed for the open sea, she is especially stable in strong winds, less susceptible to waves and therefore comfortable for the new sailor. Interior headroom is achieved simply because of the deep hull, not with high cabins and their attendant wind resistance.

The Powers' use of **HAWAITA** as a live-aboard home benefits from a very effective wood partition, dividing the main and aft cabins and offering quiet privacy when closed; sliding the doors out of the way converts the two cabins into one huge salon. Complementing a majestic staircase in the main cabin is the separate companionway aft, which provides direct access to the cockpit when the sliding partition is closed. Deep Oriental rugs silence the cabin floors, and in summer a removable canvas awning adds to the natural insulation of a wooden hull—an important consideration for the Powers' baby daughter.

Once when David and Jennifer were stopped in Corsica, they met by coincidence one of their boat's former owners, who explained how he had chosen **HAWAITA**'s name. The Powers had assumed the name was something Spanish or maybe Polynesian, but the former owner insisted that, after a particularly wild party once in a French port, he had awakened with a terrific headache aboard his recently purchased yacht, and the word "hawaita" was softly ringing in his ears. It was therefore logical to name the schooner after this exotic variety of French hangover.

Designer—J. & M. Soper
Builder—Berthon Boat Company; Lymington, Hants, England (launched 1932)
Length—73 feet 3 inches (22.33 meters) overall; 61 feet 6 inches (18.75 meters) on deck; 41 feet 6 inches (12.65 meters) at waterline
Beam Maximum—13 feet 6 inches (4.11 meters)
Draft—9 feet 9 inches (2.97 meters)
Displacement—132,240 pounds (60,000 kilograms)
Total Sail Area—3000 square feet (278.7 square meters)
Engine Data—Leyland DAF 75 horsepower diesel
Construction—teak and pitchpine plank bronze-riveted on oak frames and keel; teak deck on oak beams; interior teak, spars of Oregon pine, polyester sails
Home Port—Estepona, Costa del Sol, Spain

Glossary

Aft—the rear of a boat (as in "aft cabin").

Barque (or Bark)—a sailing vessel with three or more masts, all square-rigged except for the one farthest aft.

Beam Maximum—in modern usage, a vessel's greatest width excluding any moveable equipment or rigging.

Boom—any pole which follows the lower edge of a sail out from a mast or wire stay and holds the sail's shape.

Bow—the front end of a boat.

Bowsprit—a spar projecting directly forward over the bow of a boat and carrying extra sail area.

Brail—to gather and tie a sail against a spar, using light ropes leading from edges of the sail, then to the spar, and finally to the deck.

Brig—a fully square-rigged sailing vessel with two masts; a "hermaphrodite brig" is fully square-rigged only on the foremast and is often called a "brigantine."

Ceiling—in large wooden vessels, planking fastened to the inner surface of the hull frames, both to support cargo and to strengthen the hull.

Centerboard—used to maintain course, a flat panel rotating down from within a boat's centerline and into the passing water.

Clipper Bow—the name sometimes given to a boat's forward profile when concave.

Cutter—a fore-and-aft rigged sailboat with jib, forestaysail, and mainsail, the single mast placed farther aft than aboard a sloop.

Daggerboard—used to maintain course, a long flat panel sliding straight down through a boat's hull and into the passing water.

Displacement—the exact weight of water displaced to float a vessel and its cargo.

Double-ender—any vessel which has a tapered stern resembling the bow.

Draft—the vertical distance from the plane of the water's surface to the deepest point on the vessel's underwater form.

Floors—internal structural members joining both sides of a boat's hull to the central keel.

Fore—the front of a boat (as in "foredeck" and "go foreward").

Fore-and-Aft Rig—any sail attached along its forward edge to a mast or wire stay.

Furl—to gather and tie an entire sail against a boom, yard, or wire stay.

Gaff Rig—any fore-and-aft sail with four edges and its upper edge attached to a moveable "gaff" spar. (Modern "Bermuda" or "Marconi" rig attaches one corner of a triangular sail to the top of the mast.)

Galley—the boat's kitchen.

Garboard—in traditional wood construction, the longitudinal plank next to the keel.

Head—the vessel's toilet or bathroom.

Jibe (or Gybe)—except in square-rigged sailing vessels, to change course so that the wind crosses the stern and forces sails to the vessel's opposite side. ("Tacking" is the reverse maneuver, swinging the bow into and across the oncoming wind.)

Keel—the longitudinal backbone of a boat, starting under the bow and continuing down toward the rudderpost. (The cast-lead fin under modern sailboats is called a "ballast keel.")

Keelson (or Keel Batten, or Apron)—a longitudinal structural member which reinforces a boat's centerline above the keel.

Ketch—a fore-and-aft rigged sailboat with headsails, a mainmast, and slightly smaller mizzenmast aft; the mizzen is placed forward of the rudderpost and cockpit (see "Yawl").

Knee—any small curved brace joining the intersection of two large structural members in a boat.

Knot—a unit of speed equalling one nautical mile per hour. (One nautical mile equals 6076.1033 feet or 1852 meters.)

Lapstrake—a system of boat construction using thin overlapping planks, which are fastened to each other and to internal frames with metal rivets.

Lateen Rig—traditional in the Mediterranean, with a long moveable yard beginning forward close to the deck, crossing the top of a short mast, and reaching a high point aft. The triangular sail attaches its forward edge along the yard.

Leeboard—used to maintain course, a flat panel rotating down into the water on a boat's leeward side (away from the oncoming wind) and carried one per side.

Length Overall—in popular usage, the extreme measure of a vessel from bow to stern, including all rigging which extends beyond the hull.

Length on Deck—the measure of a vessel from bow to stern, including only the hull's upper surface.

Length Waterline—the measure of a vessel from bow to stern, taken at the water's surface.

Lug Rig—any sail having four edges, with its entire upper edge attached to a slanted yard crossing the mast.

Monel (or Monel Metal)—a trademarked non-magnetic alloy, consisting of 67 percent nickel, 28 percent copper, and 5 percent iron or manganese, and offering high strength and resistance to salt-water corrosion.

Motorsailer—any boat designed for operation alternately under sail and under power.

Port Side—while facing forward on the deck of a vessel, the viewer's left side.

Quarter-Ton (also Half, Three/Quarter, etc.)—names given to various sizes of modern racing sailboats designed to the International Offshore Rule. The names refer to a mathematical formula and not to the boat's actual weight.

Raffee—a triangular topsail added above a horizontal yard.

Reef—to reduce the exposed area of a sail by gathering and tying part of it against a boom, yard, or wire stay.

Sail Area—the total amount of sail carried by a boat under normal conditions.

Schooner—a fore-and-aft rigged sailboat with two or more masts, their height generally remaining the same or increasing as one proceeds aft, and sometimes carrying square or triangular topsails.

Sheer Clamp (or Shelf)—a longitudinal structural member joining the edge of a boat's hull to the deck.

Sheet—a rope used to control a sail's angle to the wind.

Sloop—a fore-and-aft rigged sailboat with a single mast and a single headsail.

Spar—generally any fixed or moveable pole in a sailing vessel's rig. (see Yard).

Square Rig—any rectangular sail attached along its upper edge to a horizontal yard, which at its center crosses the mast.

Starboard Side—while facing forward on the deck of a vessel, the viewer's right side.

Stern—the rear end of a boat.

Stringer (or Longitudinal)—a longitudinal structural member attached to the hull's inner surface between sheer clamp (shelf) and keel.

Studding Sails (or Stunsails)—aboard square-rigged vessels in light winds, sails temporarily extended beyond and to the sides of the permanent squaresails.

Treenail (or Trunnel)—a thick dowel used in traditional wood ship construction to fasten planks against frames.

Yacht—any sailing or motor-driven vessel which provides accommodation and recreation before any secondary purpose.

Yard—any moveable pole crossing the mast in a sailing vessel's rig, especially in square-rigged vessels (see "Spar").

Yawl—a fore-and-aft rigged sailboat with a mainmast placed forward, carrying a mainsail and one or more headsails, and with a very small mizzenmast aft of the rudderpost and cockpit (see "Ketch").